CHESTER TO MANCHESTER LINE

THROUGH TIME

Steven Dickens

AMBERLEY

First published 2016

Amberley Publishing
The Hill, Stroud, Gloucestershire, GL5 4EP
www.amberley-books.com

Copyright © Steven Dickens, 2016

The right of Steven Dickens to be identified as the Author
of this work has been asserted in accordance with the
Copyrights, Designs and Patents Act 1988.

ISBN 978 1 4456 3277 3 (print)
ISBN 978 1 4456 3288 9 (ebook)

British Library Cataloguing in Publication Data.
A catalogue record for this book is available from the
British Library.

Typesetting by Amberley Publishing.
Printed in Great Britain.

Introduction

The route covered by this book dates from the 20 July 1849 – being the date usually quoted – with the opening of the Manchester, South Junction and Altrincham Railway (MSJ&AR), although the souvenir brochure commemorating the electrification of the Manchester to Altrincham line on 11 May 1931, tells us that: 'It is of interest to recall that the Manchester, South Junction and Altrincham Railway was opened for passenger service on Friday, July 21, 1849, without any of the ceremonial usually associated with the inauguration of an important public undertaking.'

In reality the Manchester to Altrincham section of track began with an Act of Parliament, dated 27 January 1844 and the combined resources of the LNWR and the Manchester, Sheffield and Lincolnshire Railway, which led to its inauguration. The line initially terminated at Altrincham, with services extending to Bowdon in January 1850. By 12 May 1862 the line had reached Knutsford, under the management of the Cheshire Midland Railway. A further extension reached Northwich on 1 January 1863, Mouldsworth by 22 June 1870, then Helsby and Alvanley. The latter was carried out by the Cheshire Lines Committee (CLC), formed in 1862 and incorporated by an Act of Parliament dated 5 July 1865. The company was notable for lacking the word 'Railway' in its title.

The line continued to open in stages, with the Mouldsworth to Chester Northgate section opening initially to freight on 2 November 1874 and then passengers on 1 May 1875. Junctions and branch lines included the Chester to Warrington route at Mickle Trafford (LNWR and Great Western Railway, 1860), with the CLC working a branch line to Winsford and Over, which opened on 1 July 1870 and closed permanently on 1 January 1931.

In 1923 the Altrincham to Chester Northgate route remained with the CLC, until nationalisation in 1948, when CLC routes became a part of the LMR. Chester Northgate to Mickle Trafford closed to passengers on 6 October 1969, with Manchester to Altrincham closing to passengers in December 1991, and services diverted via Stockport. This was in order to facilitate the Metrolink tram service, which opened on 15 June 1992.

Deansgate, initially a station on the route, is now bypassed (as are the other former MSJ&AR stations as far as Navigation Road, due to Metrolink), with Altrincham trains heading to Manchester Piccadilly, via Stockport. The line heads towards Stockport after Navigation Road, which is shared between Metrolink and heavy rail services,

as is Altrincham Interchange. The original CLC line to Stockport utilised the MSJ&AR and connected at Skelton Junction (near Timperley), heading through Cheadle to its terminus at Stockport Tiviot Dale (both shown). Oxford Road is shown as it was the original headquarters of the MSJ&AR until 1904. The terminus at Manchester Central closed in 1969, the same year as Chester Northgate, with trains now terminating at Chester (General) and Manchester Piccadilly. For images of Chester Northgate, Manchester Central and permission to use these, I am grateful for the contribution of Roger Hepworth.

For many years the line had the reputation of being one of the busiest in the country and today serves the mainly rural communities of Mid Cheshire. It is a line of great contrasts, with its journey beginning in the historic Roman city of Chester. The former Chester Northgate station, now the site of a leisure centre, is named after one of the gateways through the city walls at Northgate Street. The journey continues through small, rural communities to the town of Northwich, whose historic roots also stretch back to the Roman occupation. Here can be seen the remaining industrial remnants of the salt and chemical industries, which brought so much economic growth to the area and led to the need for an efficient railway infrastructure to service these heavy industries. The line heads through more rural communities, to the affluent outer suburbs of Greater Manchester. These then give way to the culturally diverse city centre, with its rich heritage of Victorian railway infrastructure, much of which is now utilised by the modern and expanding Metrolink tram system.

It is for the above reasons that I have decided to concentrate on the Mid Cheshire route, rather than the alternative Chester to Manchester line, via Warrington, as I feel that it more adequately conveys to the reader the vast array of differing features to be seen, in terms of architecture, geography, economic and social diversity and – most importantly – history. To this end I have also included some images of the districts that the line passes through, rather than just stations and railway infrastructure, in order to show a changing sense of village, town and city character along the route of the line. Similarly, there are some indirectly related images of branch lines and associated stations, Frodsham for example, which is on the alternative route to Manchester Piccadilly, via Warrington Bank Quay. I hope you enjoy my efforts!

CHEAP DAY RETURN FARES — SECOND CLASS

SUBJECT TO ALTERATION
Daily by any train—First Class fares 50% more

TO and FROM	Manchester Central	Old Trafford	Stretford	Sale	Altrincham	Hale	Ashley	Mobberley	Knutsford	Plumley	Lostock Gralam	Northwich	Hartford & Greenbank	Cuddington	Delamere	Mouldsworth	Chester Northgate
Manchester Central	—	-/6	-/10	1/3	1/9	2/-	2/9	3/-	3/9	4/3	4/6	4/9	5/3	5/9	6/6	7/-	7/9
Old Trafford	-/6	—	-/6	-/10	1/5	1/8	2/3	2/9	3/3	3/9	4/3	4/5	5/-	5/6	6/3	6/9	7/9
Stretford	-/10	-/6	—	-/6	1/2	1/5	1/10	2/2	3/1	3/6	3/10	4/4	4/9	5/3	6/-	6/6	7/9
Sale	1/3	-/10	-/6	—	-/9	1/0	1/7	1/10	2/7	3/3	3/8	3/10	4/3	4/9	5/6	6/3	7/6
Altrincham	1/9	1/5	1/2	-/9	—	-/4	1/1	1/6	2/1	2/8	3/2	3/5	3/9	4/3	4/9	5/3	6/6
Hale	2/-	1/8	1/5	1/0	-/4	—	-/9	1/2	2/-	2/5	2/11	3/4	3/6	4/-	4/9	5/3	6/3
Ashley	2/9	2/3	1/10	1/7	1/1	-/9	—	-/10x	1/6	2/2	2/8	2/11	3/5	3/10	4/6	5/-	6/-
Mobberley	3/-	2/9	2/2	1/10	1/6	1/2	-/10x	—	-/11	1/8	2/2	2/5	2/11	3/6	4/2	5/3	
Knutsford	3/9	3/3	3/1	2/7	2/1	2/-	1/6	-/11	—	-/11	1/8	2/1	2/2	2/11	3/6	4/2	5/3
Plumley	4/3	3/9	3/6	3/3	2/8	2/5	2/2	1/8	-/11	—	-/10x	1/2	1/8	2/2	3/-	3/6	4/7
Lostock Gralam	4/6	4/3	3/10	3/8	3/2	2/11	2/8	2/2	1/8	-/10x	—	-/10x	1/2	1/8	2/6	3/-	4/2
Northwich	4/9	4/5	4/4	3/10	3/5	3/4	2/11	2/5	2/1	1/2	-/10x	—	-/8	1/6	2/2	2/9	3/9
Hartford & Greenbank	5/3	5/-	4/9	4/3	3/9	3/6	3/5	2/11	2/2	1/8	1/2	-/8	—	1/1	1/8	2/3	3/6
Cuddington	5/9	5/6	5/3	4/9	4/3	4/-	3/10	3/6	2/11	2/2	1/8	1/6	1/1	—	-/10	1/10	3/-
Delamere	6/6	6/3	6/-	5/6	4/9	4/9	4/6	4/-	3/6	3/-	2/6	2/2	1/8	-/10	—	1/-	2/6
Mouldsworth	7/-	6/9	6/6	6/3	5/3	5/3	5/-	4/6	4/2	3/6	3/-	2/9	2/3	1/10	1/-	—	2/-
Chester Northgate	7/9	7/9	7/9	7/6	6/6	6/3	6/-	5/6	5/3	4/7	4/2	3/9	3/6	3/-	2/6	2/-	—

x—Ordinary Return Fares

Tickets between Manchester Central and Chester Northgate are also available between Manchester Exchange and Chester General.

Manchester Central to Chester Northgate Timetable, 1961

The Cheshire Lines Committee (CLC), formed in 1862, was the second largest joint railway in Great Britain. Despite its name 143 route miles were in Lancashire, with it also being referred to as the Cheshire Lines Railway. Its purpose was to gain control of lines in Lancashire and Cheshire, thus breaking the dominance of the LNWR. In its early years Sir Edward Watkin led its expansion, with lines in Liverpool, Manchester, Stockport, Warrington, Widnes, Northwich, Winsford, Knutsford, Birkenhead, Chester and Southport.

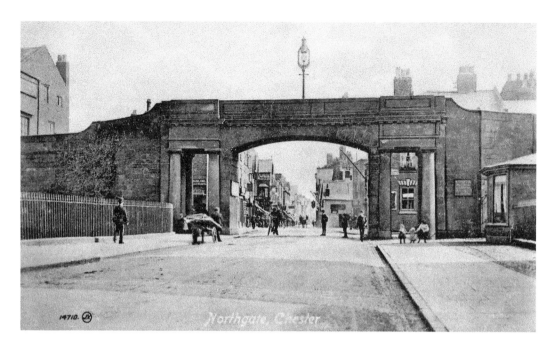

The Northgate, Northgate Street, Chester, *c.* 1900

Chester Northgate Station takes its name from the gate that carries the city walls footpath over Northgate Street. It stands on the site of the original northern Roman entrance to Chester and was later the site of the local gaol and medieval gatehouse, demolished 1808. The present Northgate was built in 1810, designed by Thomas Harrison. It stands a short distance from Northgate Arena, the site of the old Northgate Station. Lines continue towards North Wales, through Northgate Tunnel, and beneath the city walls.

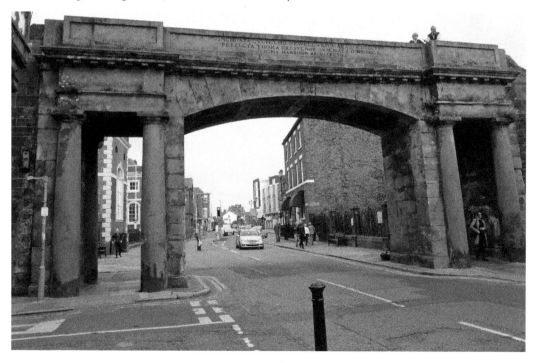

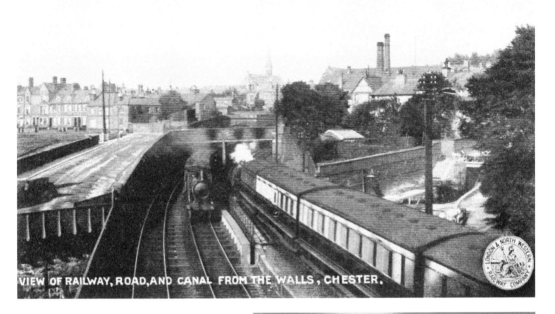

VIEW OF RAILWAY, ROAD, AND CANAL FROM THE WALLS, CHESTER.

Looking towards Northgate Church, from the City Walls, *c.* 1900 Northgate was a terminus for the Cheshire Lines Committee and Great Central Railways, with regular services to Manchester Central, Seacombe and Wrexham. Located on Victoria Road, in the Newton area of Chester, the line was originally planned by the West Cheshire Railway in 1865. In 1866 the company was acquired by the Cheshire Lines Committee. Northgate Station opened to passengers 1 May 1875 for services to Manchester Central on the Mid Cheshire Line via Northwich, and closed 6 October 1969. It is now the Northgate Arena.

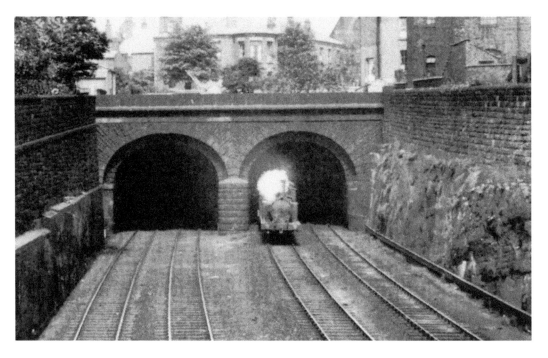

Northgate Tunnel, St Oswald's Way, Chester, 1956

Northgate Tunnel is located on the Chester to Holyhead and Chester to Shrewsbury lines, close to the site of the now demolished Northgate station, which has been replaced by the Northgate Arena. The tunnel is 218 yards in length. Today it is to be found beneath the Fountains Roundabout, at the junction of St Oswald's Way and Upper Northgate Street. While the city of Chester above it continues to develop and change, Northgate Tunnel still provides a vital link on the national rail network.

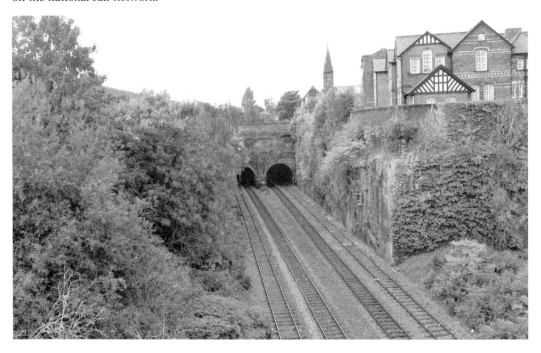

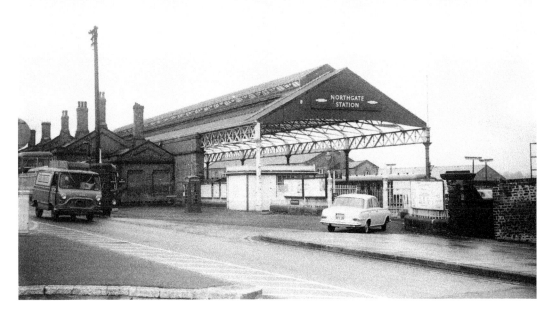

Chester Northgate, Victoria Road, 1967

Chester Northgate was located on the east side of Victoria Road. It was the northern terminus of the Cheshire Line Committee's route from Manchester to Chester, via Northwich. The line opened in four stages, with the section between Altrincham and Knutsford becoming operational on 12 May 1862; then extending to Northwich on 1 January 1863; the first goods trains reached Helsby on 1 September 1869 and included passenger services by 22 June 1870. The line reached its terminus at Chester on 2 November 1874.

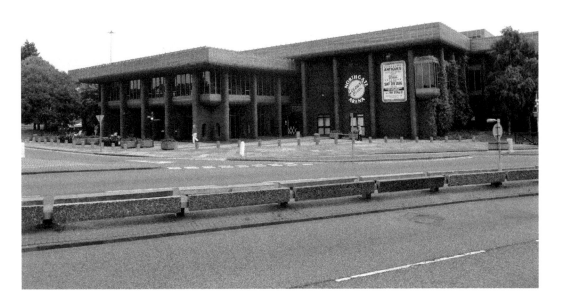

MANCHESTER CENTRAL
NORTHWICH
and
CHESTER NORTHGATE
and intermediate stations

12th June to 10th September 1961

E 15

Manchester Central, Northwich & Chester Northgate Timetable, 1961

The Cheshire Lines Committee was incorporated on 5 July 1865 by the Great Northern Railway and the Manchester, Sheffield and Lincolnshire Railway, with the Midland Railway joining in 1866.The Cheshire Midland Railway built the earlier sections. Only goods trains ran to Northgate, until 1 May 1875, when Chester Northgate station opened to passengers. It was situated only a short distance north east of Chester's historic Northgate and was much more convenient for the city centre than the GWR/LNWR Chester General station, which opened 1848.

MANCHESTER Central NORTHWICH and CHESTER Northgate

(Timetable table — WEEKDAYS services from Manchester Central via Northwich to Chester Northgate, and the return direction from Chester Northgate to Manchester Central. Detailed column-by-column times are not legible at this resolution.)

Stations listed (down direction): MANCHESTER CENTRAL dep., Old Trafford, Stretford, Sale, ALTRINCHAM & BOWDON, Hale, Ashley, Mobberley, Knutsford, Plumley, Lostock Gralam, NORTHWICH, Hartford & Greenbank, Cuddington, Delamere, Mouldsworth, CHESTER NORTHGATE arr.

Stations listed (up direction): CHESTER NORTHGATE dep., Mouldsworth, Delamere, Cuddington, Hartford & Greenbank, NORTHWICH, Lostock Gralam, Plumley, Knutsford, Mobberley, Ashley, Hale, ALTRINCHAM & BOWDON, Sale, Stretford, Old Trafford, MANCHESTER CENTRAL arr.

These Services are subject to alteration.

A—Arrives Northwich 6.41 a.m. B—Arrives Northwich 6.54 p.m. C—Arrives Northwich 6.29 p.m.
E—Arrives Northwich 8.56 a.m. F—Arrives Northwich 8.12 a.m. G—Arrives 7.9 p.m. H—Stops at Brooklands at 3.57 p.m. SO—Saturdays only SX—Saturdays excepted †—Steam Train.
Frequent diesel services operate between Chester Northgate and Wrexham, Shotton and New Brighton The service between Chester and New Brighton also gives connections to West Kirby, Birkenhead and Liverpool.
For complete service between Altrincham and Manchester (Oxford Road), see other folder.
Particulars may be obtained from Stations.

Chester Northgate in 1967, Junction of Victoria Road and St Oswald's Way

Chester Northgate had two platforms, with the main station buildings providing the amenities which passengers expected of a large terminus building. In 1967 there was a sign, located on Victoria Road (*right*), redirecting potentially confused passengers who required Chester General Station! To the east of Chester Northgate was a goods station, including nine sidings and a large goods shed, which closed on 5 April 1965. An engine shed and turntable opened 1 May 1875 on the eastern approach to the station, closing January 1960.

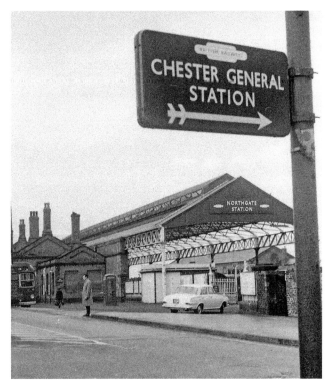

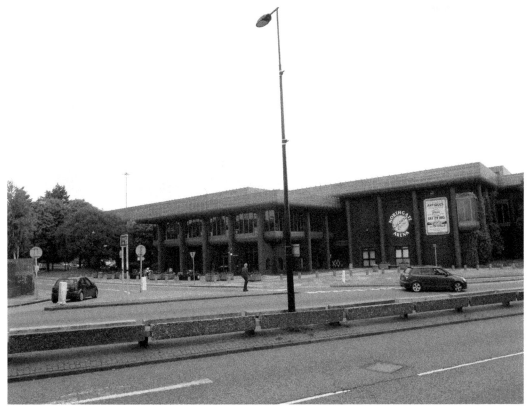

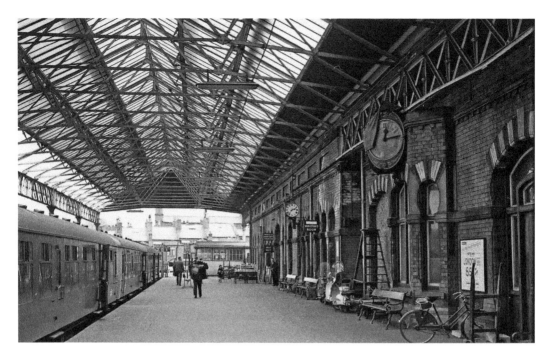

Chester Northgate Platform, 1967 and Site of Former Station Goods Yard, 2016
The station originally had two canopies, until *c*. 1966, when the one to the left of this 1967 photograph was demolished. The partially covered original station clock (right), would appear not to be functioning, with a time of 12.14, although the ladder beneath it at least gives us hope it may be repaired. The modern image shows the site of the former station goods yard (*inset*, and *below*), with – just visible – old and disused rails heading into the trees.

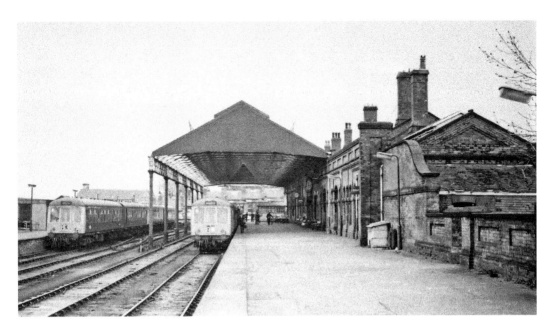

Chester Northgate Platforms and Canopy, 1967 and Surviving Station Railings, Victoria Road, 2016

This image of Chester Northgate gives us a clearer view of the site of the demolished canopy, on the left of the station site. This originally provided cover for the left-hand platform and was identical to the surviving canopy of 1967. A modern shelter was constructed for the convenience of passengers. Today, as shown in the modern image (*below*), the station railings running along the centre of Victoria Road, opposite Northgate Arena, are all that remains of the original station.

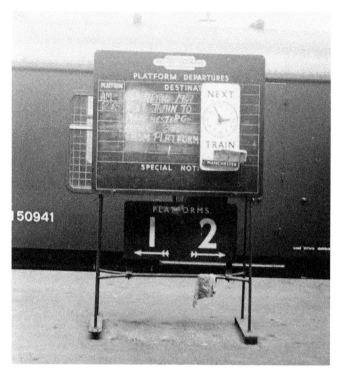

Chester Northgate Departure Board, 1969 and Northgate Church, above Northgate Tunnel, 2015

On 29 April 1969 the departure board at Chester Northgate informs us that the next train to Manchester Central leaves at 21.55 from platform one, then 2.55 from platform two. This board is a far cry from the modern digitised information terminals we have become used to in the twenty-first century. Below is a modern image of Northgate church, located at the Fountains Roundabout, on Upper Northgate Street, above Northgate Tunnel. The church was a visible landmark from the former station's entrance.

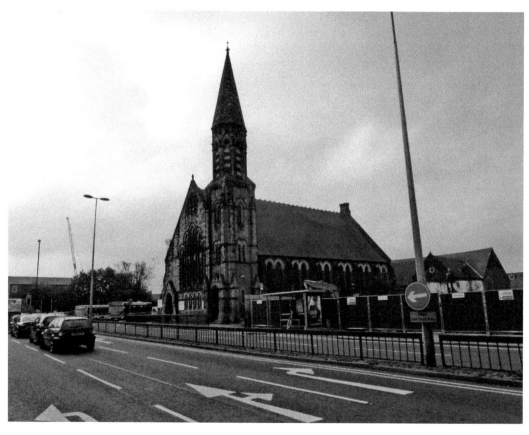

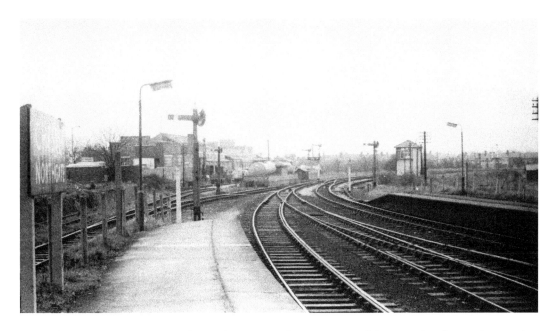

Chester South Signal Box from Chester Northgate, 1967 and former Signal Box Site, 2016
Chester South Signal Box had thirty-two levers, working from its opening in 1889 until closure on 6 October 1969. Chester Northgate had a station building, with a covered roof for each platform and four tracks with two side platforms. The central tracks were used to store carriages. One of the roofs had been removed by *c*. 1966. Additional sidings led to a locomotive yard, now disused. The area shown in the 1967 photograph has now been extensively redeveloped, with buildings and a car park (to the left of the below image).

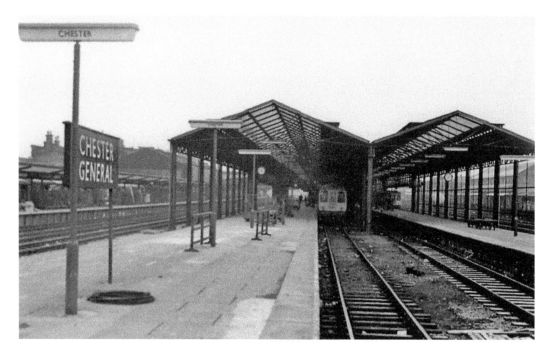

Chester General (GWR and LNWR), Station Road, c. 1965

Chester General was constructed in 1847–48 by C. H. Wild, who designed the train shed, and Francis Thompson (1808–95), with some involvement by Robert Stephenson (1803–59). The contractor was Thomas Brassey (1805–70), one of the most influential of the nineteenth century, who is commemorated by a small plaque. The station served several railway companies and until the closure of Chester Northgate in 1969, was named Chester General, in order to distinguish it from its neighbour. The modern image is from Brook Street Bridge.

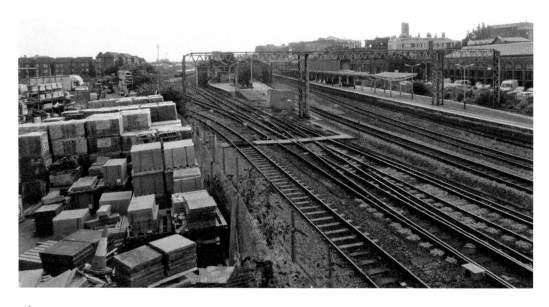

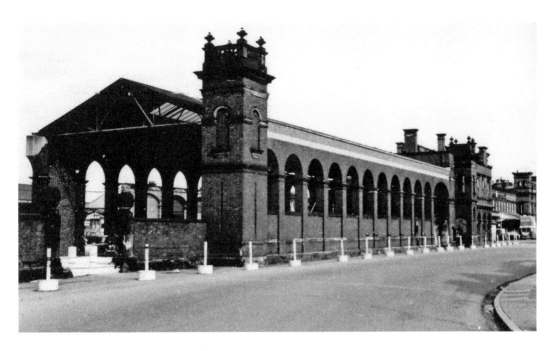

Chester General, Station Road, *c.* 1960

Located to the north-east of the city centre, the station is built of Staffordshire blue brick and pale grey Storeton sandstone, with slate roofs. Its design can be described as Italianate, with the middle seven bays of the station's central section containing carvings by John Thomas (1813–62). It is a Grade II-listed building. Arriva Trains Wales, Merseyrail, Northern Rail and Virgin Trains operate out of the station, although at the time of writing this arrangement may be subject to change.

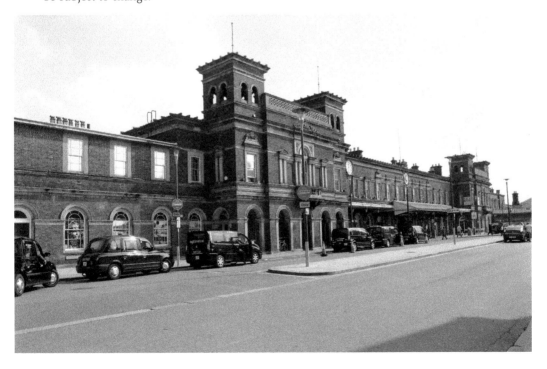

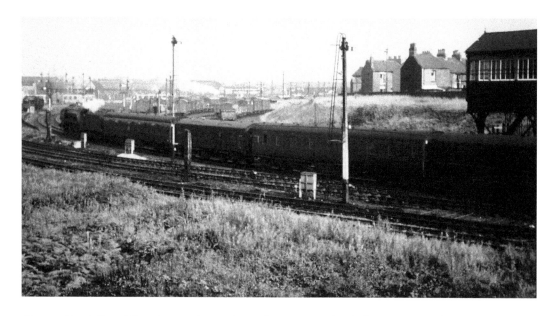

Chester No. 6 Signal Box, September 1963, and Western Exit of Chester General, 2015
This was the most distinctive signal box at Chester, mounted on a gantry above the Shrewsbury lines at the western exit of Chester General. It was built by the LNWR in 1903 and closed during the Chester resignalling. The signal box stood over the 'slow' lines to North Wales, which were later used for traffic to and from Shrewsbury. Chester Northgate and Tunnel are to the west. The photograph of 1963 shows the signal box and lines heading west towards Chester Northgate.

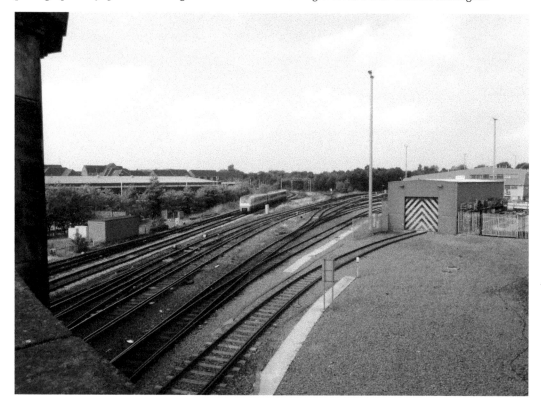

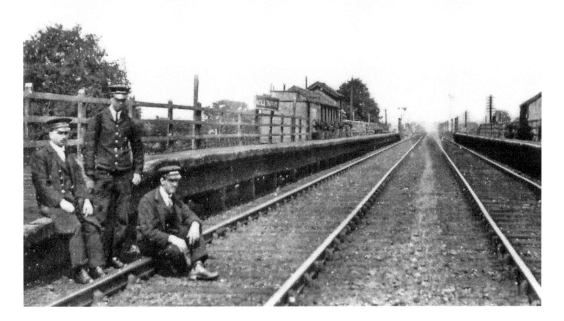

Mickle Trafford, Station Lane, *c. 1900*

This photograph shows the Chester/Warrington line and station buildings of the Birkenhead Joint Railway, opened 1 May 1875 and closed 2 April 1951. This ran alongside the CLC station, known briefly as Mickle Trafford East from 5 June 1950, until closure on 12 February 1951. It opened 2 December 1889, with its goods yard closing 1 July 1963. The respective lines were briefly connected on 4 October 1942 for wartime freight, resulting in 'staggered' platforms. Altered several times, the junction is now controlled by Mickle Trafford Signal Box (*inset*).

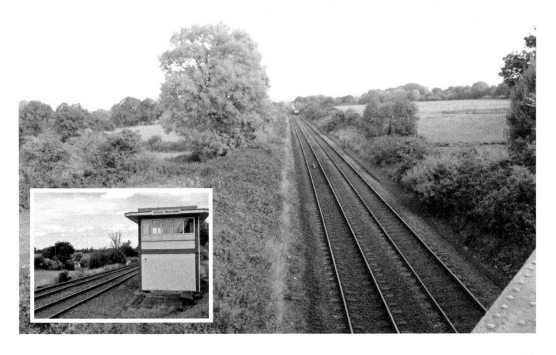

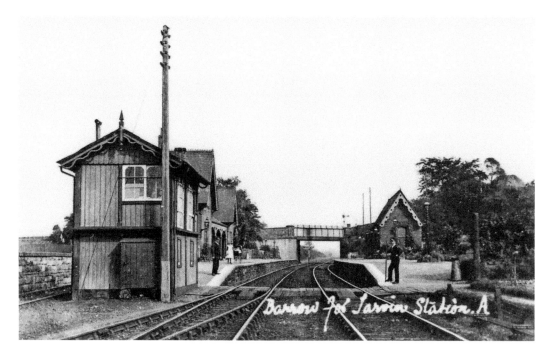

Barrow for Tarvin, Barrow Lane, *c*. 1900

Opened 1 May 1875 and closed 1 June 1953, the station building remains and is on private land. It was situated on the CLC's Mouldsworth to Chester Northgate line, opening on 2 November 1874, thus creating a second Chester to Manchester route. It was located close to the village of Little Barrow and was named Tarvin and Barrow, becoming Barrow for Tarvin in November 1883. The modern photograph is taken from the B5132 bridge, with the *c*. 1900 photograph from the station platform, looking towards the bridge.

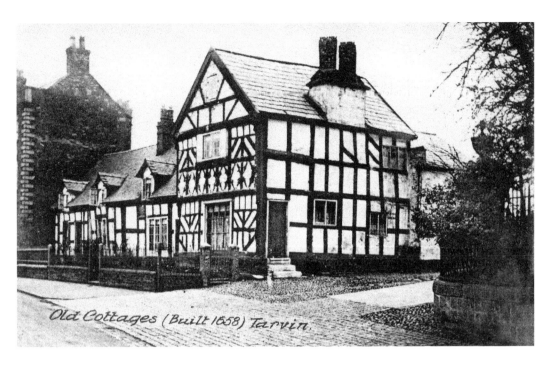

Old Cottages (Built 1658) Tarvin.

Church Cottages, Church Street, Tarvin, *c.* 1900

From 1875 Tarvin was indirectly served by Barrow for Tarvin railway station, which was more than 2 miles away. The village is noted for the Great Fire of Tarvin, which broke out on Monday 30 April 1752. The only timber-framed buildings to survive were Church Cottages and Bull's Cottage. Church Cottages are located next to the Grade I-listed St Andrew's Church, which still bears some scars from the English Civil War in the shape of canon and musket ball holes.

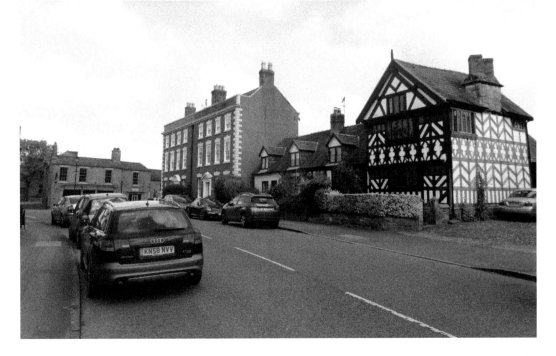

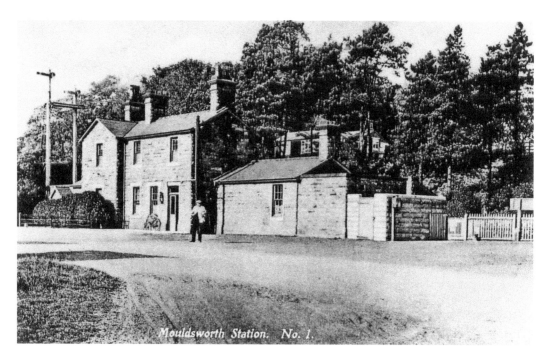

Mouldsworth, Station Road, *c.* 1900

The station opened 22 June 1870 as part of the West Cheshire Line from Northwich to Helsby and Alvanley. This company later formed part of the CLC. The line to Chester Northgate from Mouldsworth opened 1874. This became known as the Chester and West Junction Railway, which also formed part of the CLC. Once a junction, as shown by the signals on the left, Mouldsworth's signal box was demolished in 2006. The main station buildings on the Chester bound platform are now business premises. The inset shows the 12.30 p.m. Chester bound train at Mouldsworth Station.

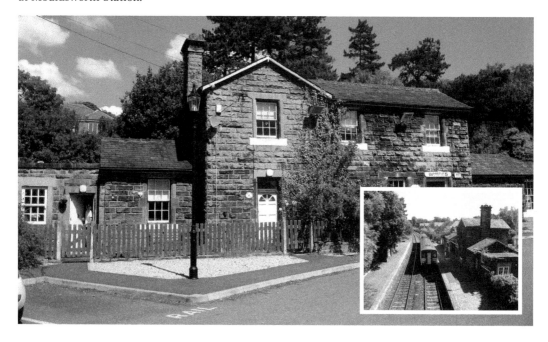

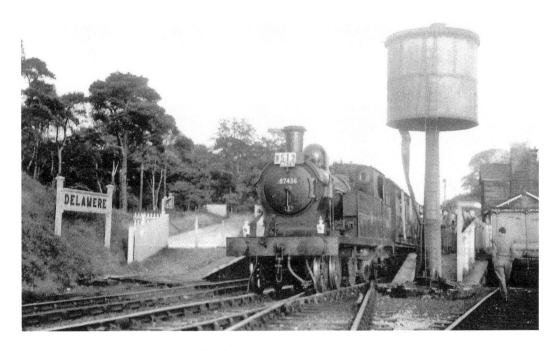

Delamere, Station Road, 17 October 1953

Delamere station opened on 22 June 1870, serving the village of Delamere and the wider area of Delamere Forest, which is today popular with walkers. The station is located on the B5152 Norley Road, which runs through Delamere Forest. Today it is unmanned and there is a café located in the former station house. Originally a part of the West Cheshire Railway's line from Northwich to Helsby and Alvanley, it has won a number of awards in the 'Cheshire Best Kept Station' competition.

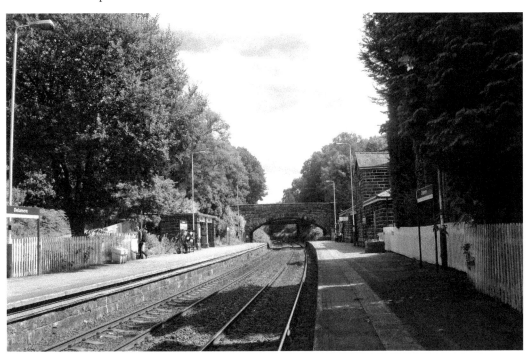

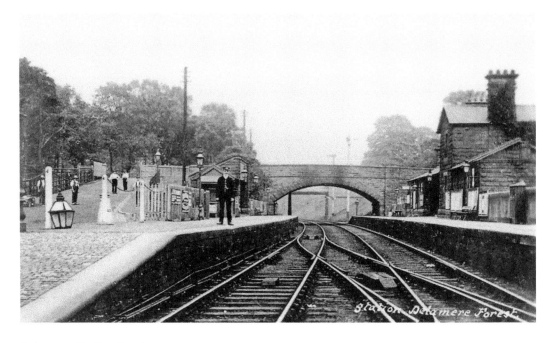

Delamere, Station Road, *c.* 1911

The steep roadway on the left was added in 1911 to ease the transportation of milk churns. In the distance, beyond the road bridge, is the Vyrnwy Aqueduct, carrying water to Liverpool. Delamere station's goods yard, to the right of the main buildings, closed on 9 March 1965 and is now a car park for the Delamere Forest Visitor Centre. The former signal box, on the left and behind the photographer, had twenty-two levers and was decommissioned on 16 May 1976.

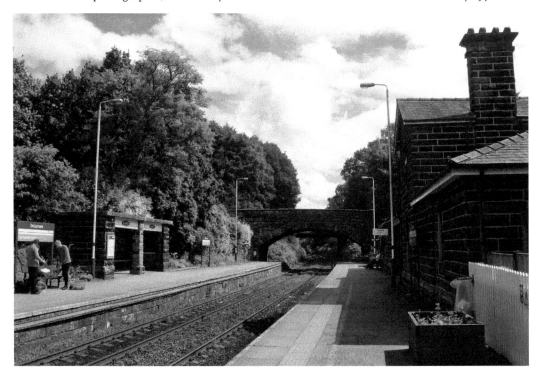

Delamere Deviation, Map of Intended Route, West of Northwich, 1861

North of the railway is the Parish of Tarvin and the Township of Ashton and to the south is the Township of Kingswood and the Parish of Eddisbury. The black unbroken line is the 'Centre line of Railway No. 1, authorised by the West Cheshire Railways Act 1861 and as shown on the deposited plan.' Bisecting the line is a 'Parish and Township Boundary', with the Parish of Delamere to the west and the Parish of Tarvin and Township of Ashton to the east.

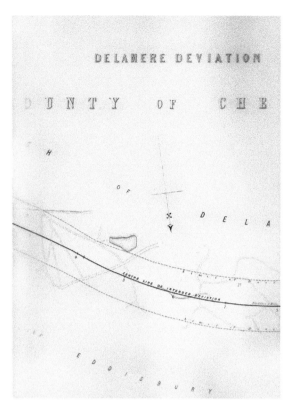

Delamere Deviation, Map of Intended Route, East of Mouldsworth, 1861
The black unbroken line shows the 'Centre line of intended deviation', presumably the route of the intended railway track, with the broken lines either side of the centre line the 'Limit of deviation', presumably to take into account embankments and earthworks. To the north is the Parish of Delamere and to the south is the Parish of Eddisbury. The line cuts across many established rights of way (*inset*). The map shows the 'curve' taking into account the nature of the terrain and parish boundaries.

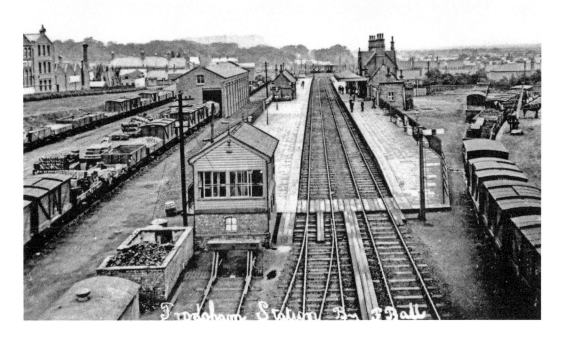

Frodsham, Church Street, *c.* 1900 and Cuddington, Junction of Norley Road and Warrington Road, 2015

Cuddington's station opened to passengers in 1870. Its signal box opened in 1886 and had thirty levers, closing 15 May 1976. The goods yard closed on 2 March 1964. An additional branch (now the Whitegate Way Country Park) terminated at Winsford, with a further branch to Helsby and Frodsham. Wealthy commuters from Manchester, Chester and Northwich began to build their mansion houses in the area, which led to the development of shops and businesses around the station, serving the increase in population.

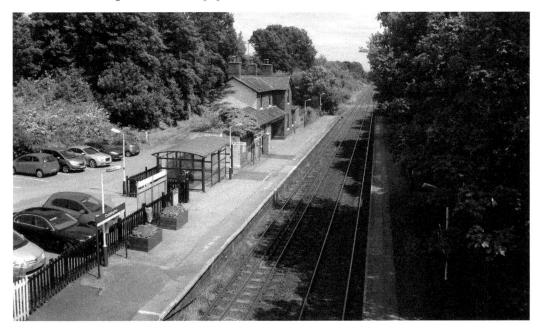

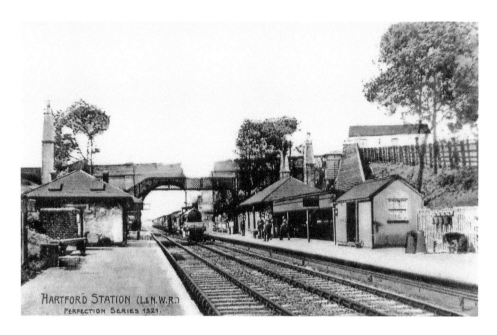

Hartford (LNWR), Chester Road, Northwich, *c.* 1910

The station was built by the Grand Junction Railway and opened in September 1837. It became a part of the London and North Western Railway on 16 July 1846, which then became part of the London Midland and Scottish Railway in 1923. The line was later nationalised by British Rail on 1 January 1948 and operated by the London Midland Region of British Rail. The station's buildings were altered at the time of the West Coast electrification in the 1960s.

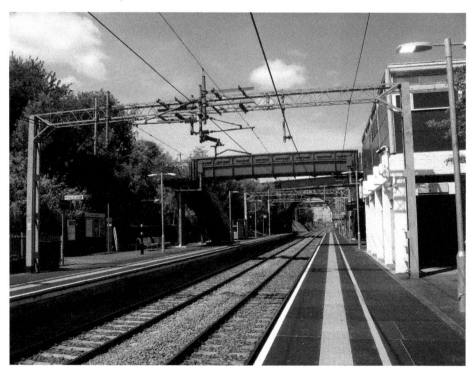

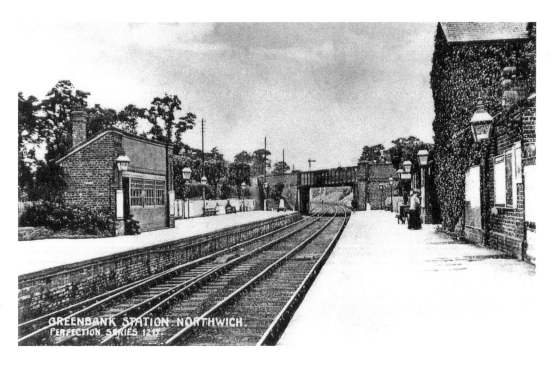

Hartford and Greenbank, Chester Road, Northwich, *c.* 1900

The CLC's station, now Greenbank, is around 1 mile from Hartford station, towards Northwich, serving Hartford village as well as the Greenbank and Castle areas of Northwich. It is situated on the A559 Northwich to Chester road. The station was built by the West Cheshire Railway – later a part of the CLC – and opened on 22 June 1870. The company continued to operate goods and passenger services from Hartford and Greenbank despite the reforms of 1923, until the railways were nationalised in 1948.

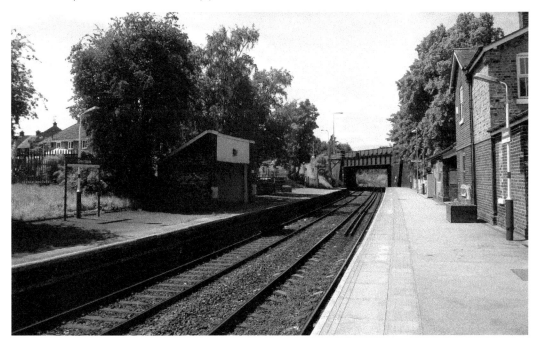

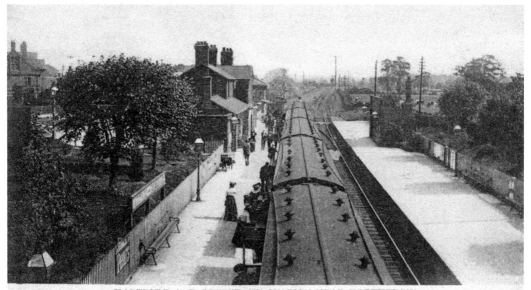

HARTFORD AND GREENBANK STATION NEAR NORTHWICH

Hartford and Greenbank, Chester Road, Northwich, Looking East, 1904

The station was named Hartford and Greenbank until 7 May 1973 when British Rail renamed it Greenbank, so as to avoid any confusion with the nearby Hartford station. The main station buildings are on the northern side of the line and are at present used as a church, known as Christ Church. There is a signal box situated to the east of the station, opened 1886, rebuilt and reopening 21 December 1975. Greenbank is utilised as an interchange for Hartford station on the West Coast main line.

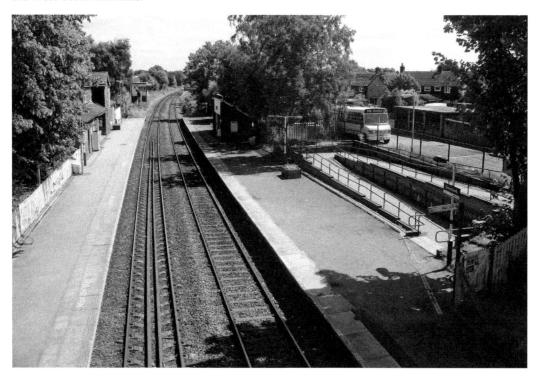

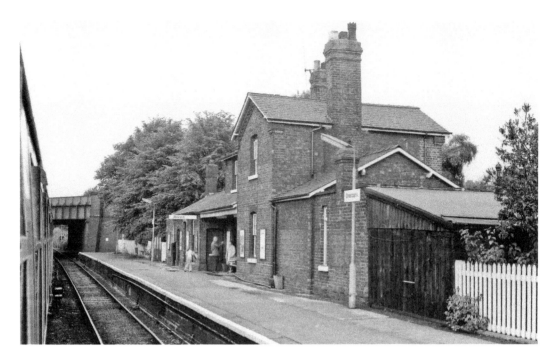

Greenbank, Chester Road, Northwich, 1 August 1974
The station originally had a connection to its own goods yard, but this closed on 30 April 1974, just prior to the date of the above photograph. The view is taken from a Chester bound train. The station buildings are now used by Christ Church, an associate church of St John the Baptist at Hartford. Christ Church opened in the autumn of 2002, serving the parish of Hartford and Greenbank. The station is also close to the Hartford campus of the Mid Cheshire College.

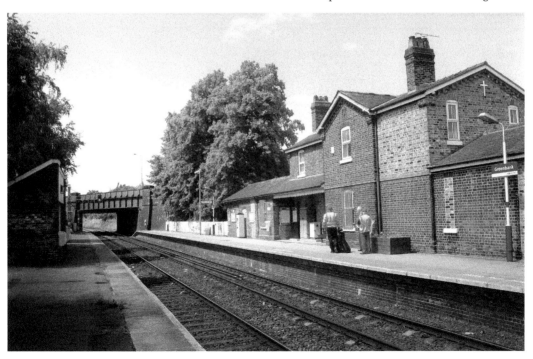

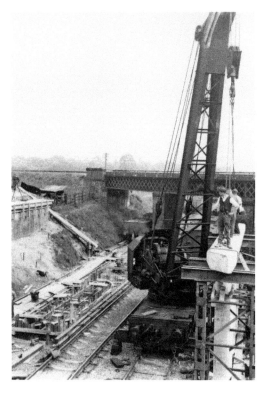

Rebuilding Hodge Lane Road Bridge Over the LNWR Main Line at Hartford, 22 January 1960, also Showing the Mid Cheshire Line Bridge

The bridge ID number is 33, an 'over-line' bridge carrying the Mid Cheshire Line over the West Coast Main Line. The Weaver Junction here allows traffic to access the main line near Acton Bridge, or to continue towards Cuddington and Chester. The photograph shows the main line (*below*), looking towards Hartford station and the Mid Cheshire Line crossing the main line, as Hodge Lane road bridge is reconstructed. To the left is Northwich and to the right is Cuddington and Chester.

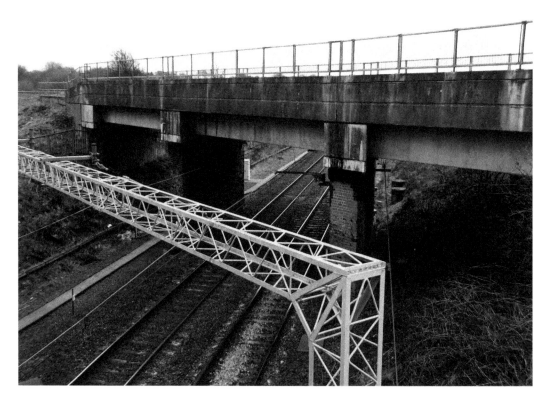

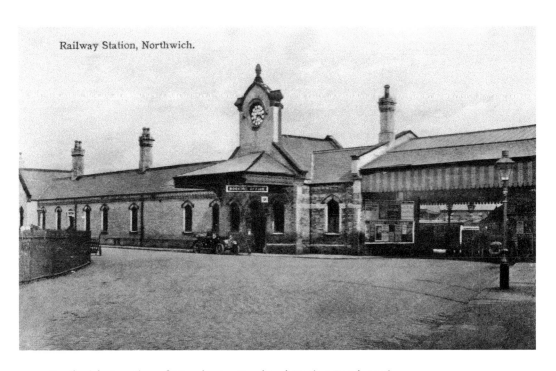

Railway Station, Northwich.

Northwich, Junction of Manchester Road and Station Road, 1916

In 1916 granite cobblestones formed the approach to the main entrance at Northwich station. The station buildings and clock tower were completed in 1897 and the building extension on the right was once used for parcel traffic in later years. Today this view is dominated by motor traffic, the front of the building being used as a car park. The extension on the right has now been demolished. The station building houses a café and Community Learning Centre.

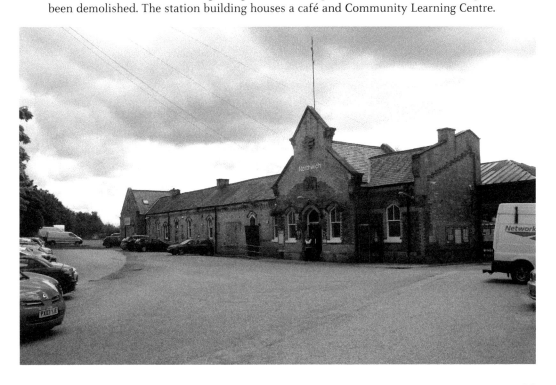

33

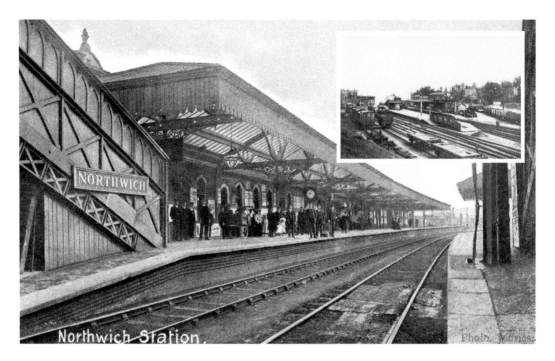

Northwich, Junction of Manchester Road and Station Road, *c.* 1900

On Sundays there is a two-hourly service to Chester and Manchester, with the latter continuing to Wigan Wallgate and Southport. Before this there had been no through trains to Manchester since 1991, with passengers changing at Altrincham onto the Metrolink. There is also a freight line, behind platform two, heading to Sandbach (*inset, c.* 1900), via Middlewich. This platform formerly operated trains for Crewe, via Sandbach, with a branch leading to the Lostock Salt Works. The goods yard, now a supermarket, closed 22 September 1969.

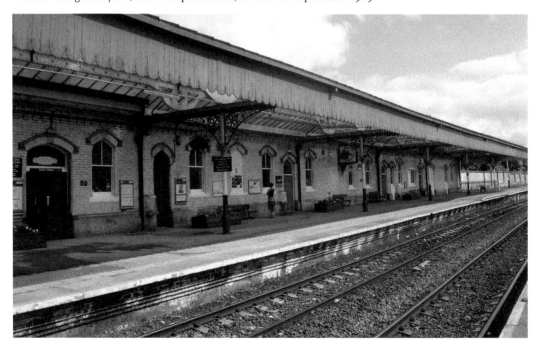

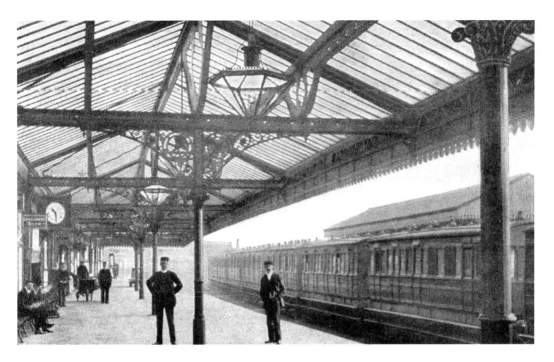

Northwich, Junction of Manchester Road and Station Road, *c.* 1900

The route to Middlewich and Sandbach (far right in the modern image), opened in 1957 for freight and diverted trains and lost its passenger service 4 January 1960. In 1992 there was a temporary period of complete closure north of Middlewich. There were three Salt Union branch lines, opening in 1867. Number three ran to the west, above Northwich town centre, to Witton Works, serving the Terra Cotta Works until *c.* 1950, and closing in 1955. There was also a siding to the gasworks until 1953.

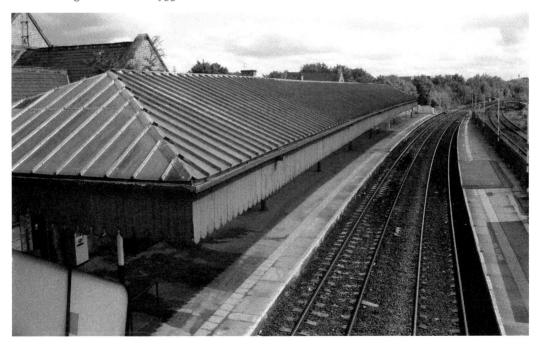

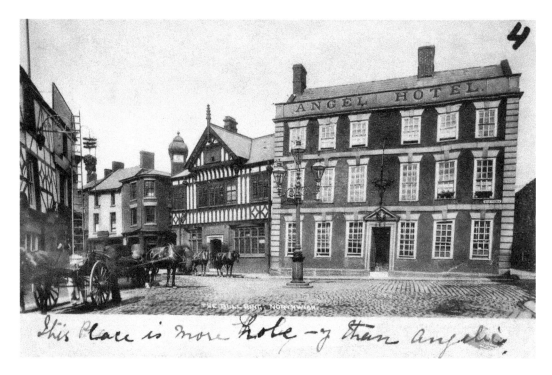

This Place is more hole-y than angelic.

The Angel Hotel, Bull Ring, Northwich, 1903
The Angel Hotel was built in 1790, on the site of a much smaller public house of the same name. It was frequented regularly by gentlemen from around the country, whose stagecoaches stopped there until the advent of the railways. It was also visited by a sixteen-year-old Princess Victoria in 1835 and was an important site for civic occasions. It was sold twice in the latter nineteenth century, severely damaged by subsidence in the early 1900s, and demolished in 1922.

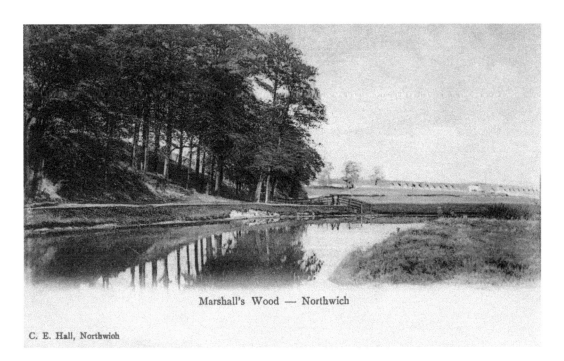

Marshall's Wood — Northwich

The Railway Viaduct from Marshall's Wood and the Weaver Navigation, Northwich, c. 1900
The West Cheshire Railway left Northwich in a south-westerly direction and crossed the rivers Dane and Weaver by means of a half-mile long viaduct and two wrought-iron girder bridges, with a clearance of 69 feet above water level. The old course of the River Weaver was made navigable from c. 1730–1800 in order to straighten the river for commercial salt barges and construct Hunt's Lock. The Marshall family of nearby Hartford Manor were influential in this development.

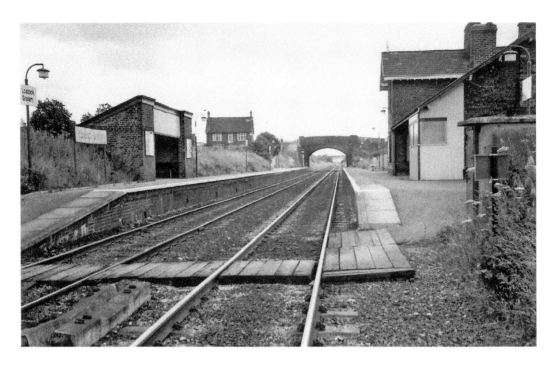

Lostock Gralam, Station Road, *c.* 1960

There was once a goods yard here, which ceased operations on 3 August 1964. ICI's Lostock Works, which began production in 1891, is close by. The Chester-bound platform on the right of the image once housed a terrace of cottages for railwaymen, these were demolished in the 1960s. The Manchester-bound side had a signal box, which closed on 19 January 1969. The station takes its name from the village of Lostock, Gralam being the name of a former inheritor of the manor.

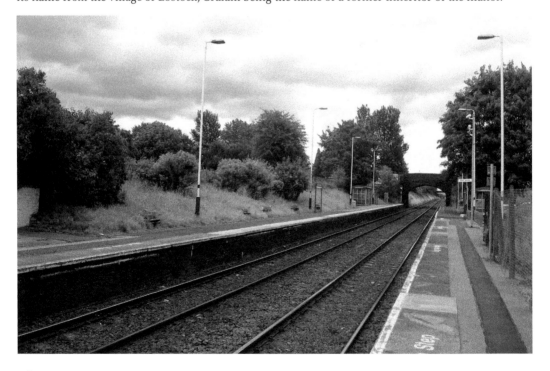

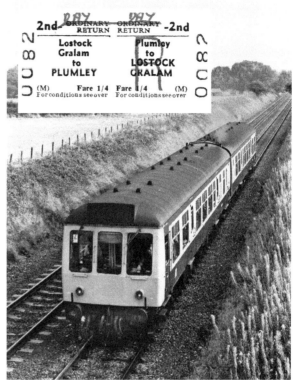

Manchester-bound Express Approaches Lostock Gralam, Station Road, 3 October 1988

The inset image above shows a return ticket to Plumley from 1968. The main station building was demolished on Sunday 8 July 2007. Lostock Gralam was once downgraded to a request stop, then in summer 2011 new passenger shelters were constructed on both platforms. It is no longer a request stop. A new commercial building and car park is planned for the station, which has won an award in the Cheshire Best Kept Station Competition. In 2011 it won the most improved station award and is close to the Lion Salt Works 'living museum', opened 2015.

LNER Class V2 No. 4771 Green Arrow at Plumley, Plumley Moor Road. Chester to York Excursion, 16 September 1991
Green Arrow was built in June 1936 for the LNER at Doncaster Works, to a design by Nigel Gresley. It is the first built and only surviving member of its class. It was designed for hauling express freight and passenger trains and is named after an express freight service. It was withdrawn from service in August 1962, selected for preservation and restored at the Doncaster Works, which was completed in April 1963. It is currently housed at the National Railway Museum, York.

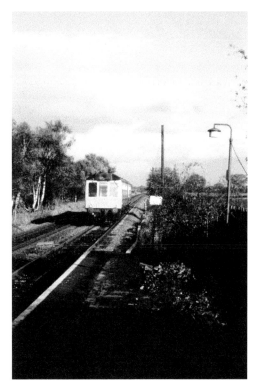

Chester-bound DMU at Plumley, Plumley Moor Road, 9 November 1989

The station's name was originally Plumbley until 1 January 1945. There was a goods yard at the station, which remained in use until 3 February 1964 and a signal box, which functioned from 1886 until 10 January 1965. Plumley West Box opened in 1903 and a siding, from 1938 to 1989, was used by a company producing petrol additives. During the First World War there was a munitions factory siding and a halt west of the station. The station buildings are now used as a private dwelling.

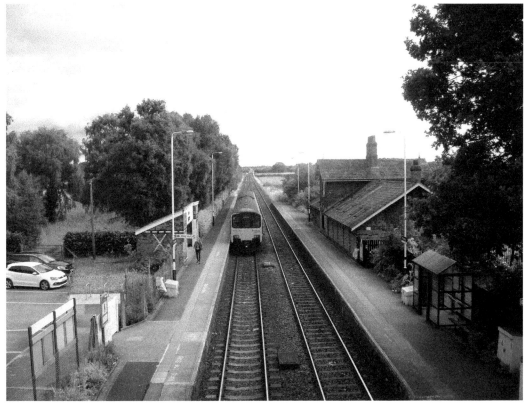

Plumley in the Snow, Plumley Moor Road, 24 January 1984, and Plumley Station

The station is 33 kilometres (20.5 miles) east of Chester, on the Mid Cheshire Line to Manchester Piccadilly. Until the 1930s, when houses were constructed as part of a national housing boom, Plumley was almost exclusively a farming community, reliant upon agriculture for its survival. There are two good quality public houses in the village, the Golden Pheasant, which is close to the railway station and the Smoker. Plumley station is convenient for Tatton Park Gardens and Arley Hall and Gardens.

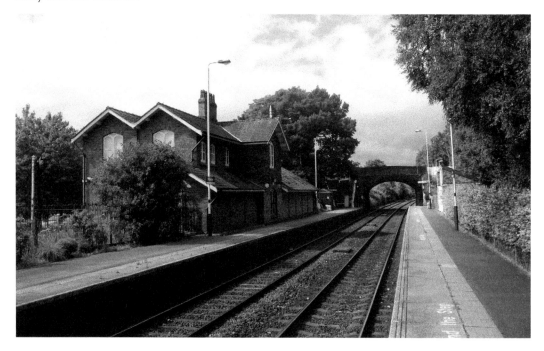

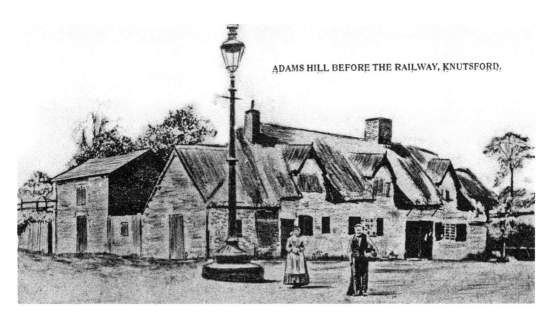

ADAMS HILL BEFORE THE RAILWAY, KNUTSFORD.

Adam's Hill Before and After the Railway, Knutsford

The novelist Elizabeth Gaskell (1810–65) is buried at Brook Street Unitarian Chapel, which was founded in 1688 and located at Adam's Hill. In *c.* 1860 the area was occupied by the farm shown in the image above, until the station was constructed. Later the station's goods yard was originally on the south-east side of the railway track, above the towering brick retaining wall. Then it was re-sited to the north and the original site became the station master's garden.

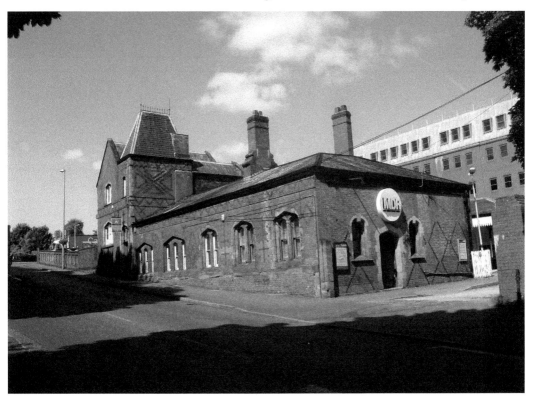

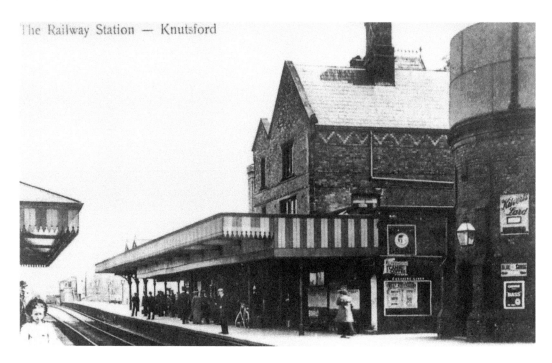

Knutsford, Junction of Adam's Hill and Toft Road

To the right of the above view from 1905 the station's water tank can be seen, now replaced by a modern shelter in the view from 2015. There was once an engine shed at the station and the East Signal Box was built in 1886, being decommissioned on 27 October 1996. The West Signal Box worked goods yard traffic until 1 May 1966, with the goods yard closing on 30 June 1969. A private siding at Shaw Heath, east of Knutsford station, was a wartime petrol depot.

14.00 Chester-bound DMU at Knutsford, from Toft Road Railway Bridge, 8 July 1985

Knutsford station, which is 35 kilometres (21.75 miles) south of Manchester Piccadilly, opened to passengers on 12 May 1862 with a service between Knutsford and Altrincham. Trains to Northwich began operating on 1 January 1863. Services were operated by the CLC, until the railways were nationalised on 1 January 1948. The station was located on the site of a farm mentioned in Mrs Gaskell's novel, *Cranford*, where a cow fell into a lime pit. The East Signal Box can be seen on the far right of the 1985 image.

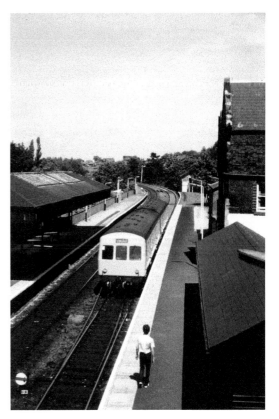

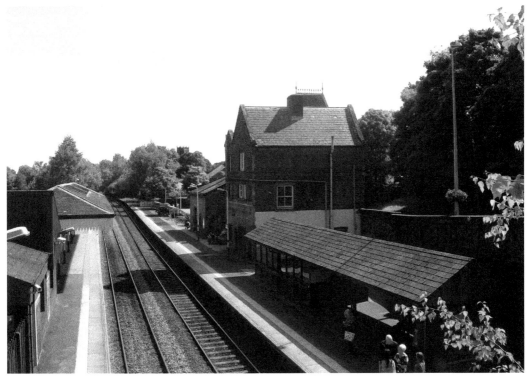

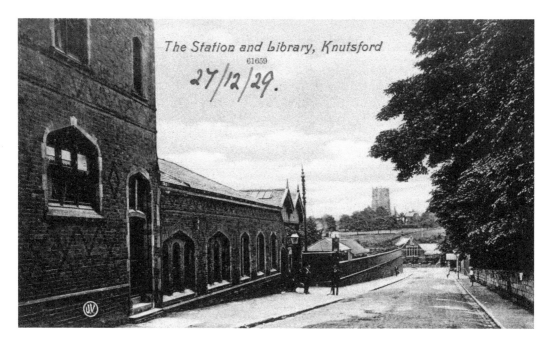

The Station and Library, Knutsford
61659
27/12/29.

Knutsford Railway Station, Library and St Cross Parish Church, 1929

The church shown is St Cross on Mobberley Road, a Grade II-listed building consecrated in February 1858. The main part of the church was built between 1880 and 1881, to a design by the Lancaster architects Paley and Austin. The tower was finished in 1887 and the church completed 1889, being enlarged in 1906 with added aisles. The public library of 1904 was by Manchester architect, Alfred Darbyshire, with funding from the Carnegie Trust. Located on Brook Street, the building is Grade II listed.

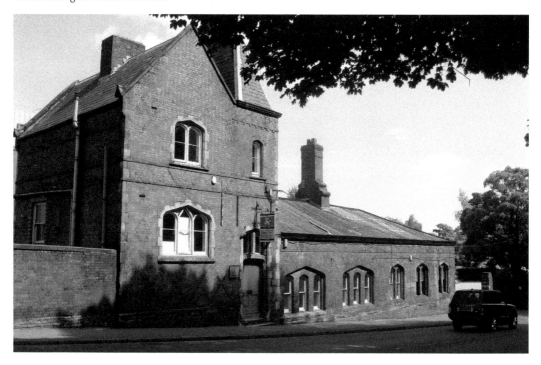

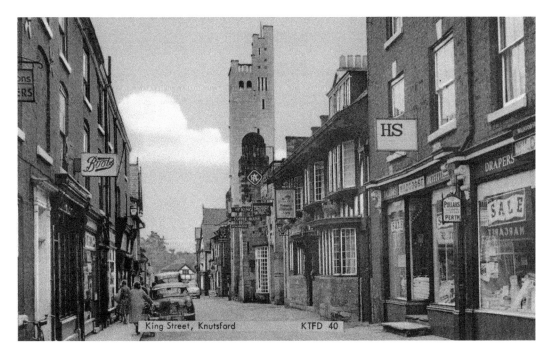

King Street and Gaskell Monument, Knutsford, *c.* 1960

The Gaskell Memorial Tower and King's Coffee House was originally council offices, a coffee house and a memorial to the novelist Elizabeth Gaskell, a former resident of the town. The building was designed by Richard Harding Watt, with assistance from W. Longworth, as Harding Watt was not a qualified architect. It was opened on 23 March 1907 and is a Grade II-listed building. Since the early 1970s it has been used as a restaurant and is close to the station (far right).

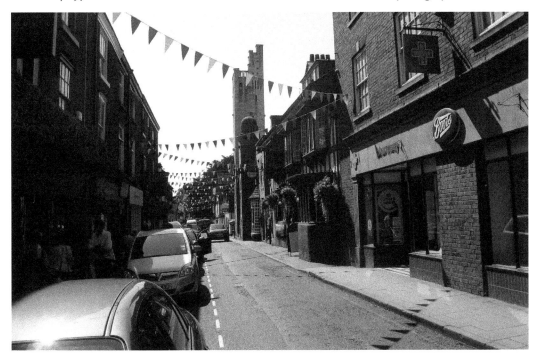

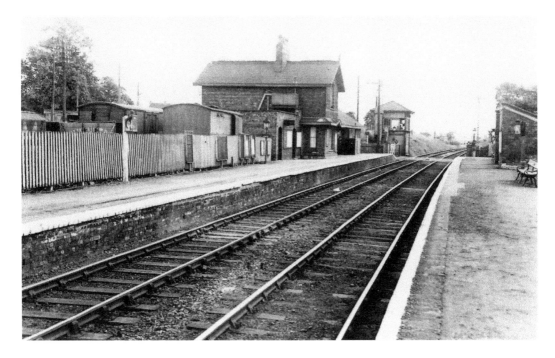

Mobberley, Station Road, Looking Towards Chester, *c.* 1900

The station is situated to the north of the village, just over 1 mile from the church and the oldest part of Mobberley with its picturesque cottages. It is thirty kilometres (18.5 miles) south of Manchester Piccadilly. The station was opened on 12 May 1862 by the Cheshire Midland Railway, which was absorbed by the CLC on 15 August 1867. The manual barriers, shown next to the signal box, were replaced by automatic ones in 1978. Mobberley was, until 12 December 2010, a request stop only.

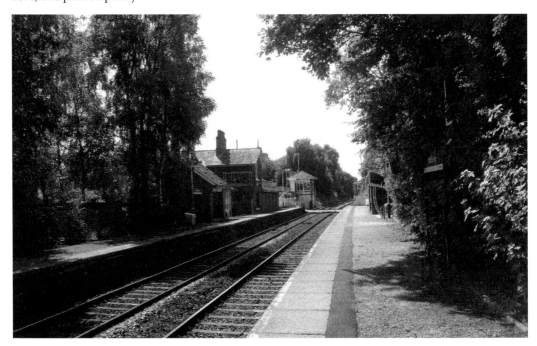

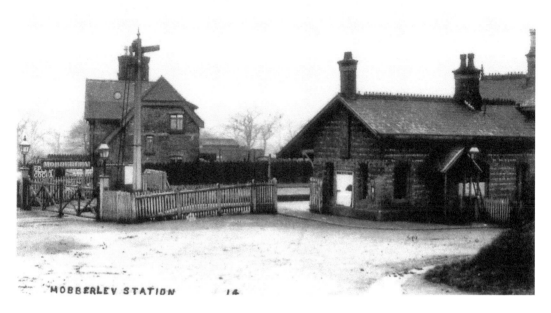

Mobberley, Station Road, *c.* 1900
Next to Mobberley station there are several railway cottages and the Railway Inn, which was formerly a mill house that was converted to a public house *c.* 1860 when the railway line was built. Shown are the original *c.* 1900 gas lamps on the barriers, which are now modern signals. Close to Manchester Airport, the station is a previous winner of the Cheshire Best Kept Station Competition, 2004; the Roberts Bakery Award, 2005; Cheshire's Tidiest Station, 2006; and the Cheshire Community Award, 2007.

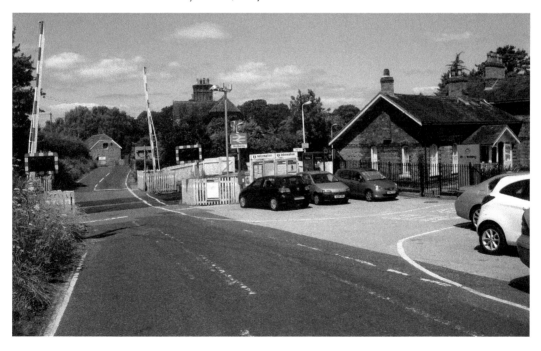

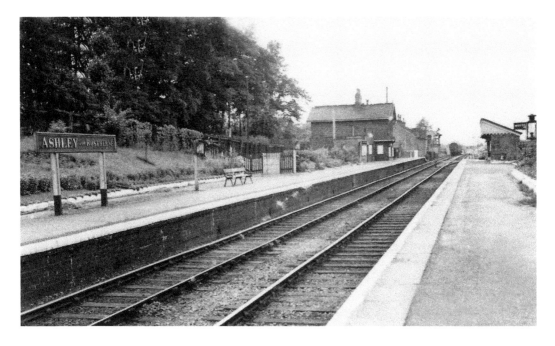

Ashley for Rostherne, Ashley Road, 1900

The station opened 12 May 1862, as part of the first phase of the Cheshire Midland Railway's line from Altrincham to Knutsford. The Cheshire Midland Railway was later absorbed by the CLC, 1867. The main Ashley station house building on the Manchester-bound platform is now a private dwelling. The 1886 signal box was decommissioned 14 June 1964, 'For Rostherne' was dropped around 1955 and the goods yard closed 6 March 1961. The cricket club and the Greyhound public house are a short walk away.

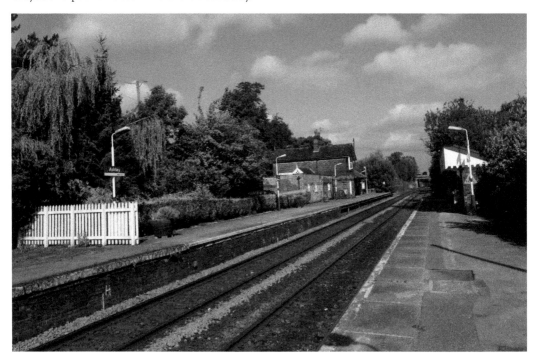

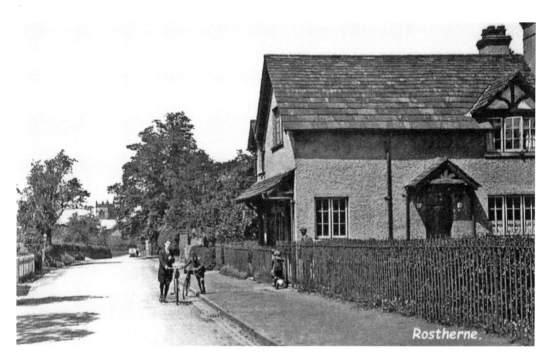

Rostherne.

Rostherne and St Mary's Church, Rostherne Lane, Near Altrincham, *c.* 1910

Close by is the village of Rostherne and the parish church of St Mary, a Grade I-listed building. Its rectory was for many centuries in the possession of the Leigh family of West Hall, High Legh. The church is Perpendicular in style, with a lych gate dating from 1640. Rostherne Mere is a National Nature Reserve and the deepest, at 30 metres, and largest mere in Cheshire. The village is 3 miles from Knutsford and adjacent to the hamlet of Ashley.

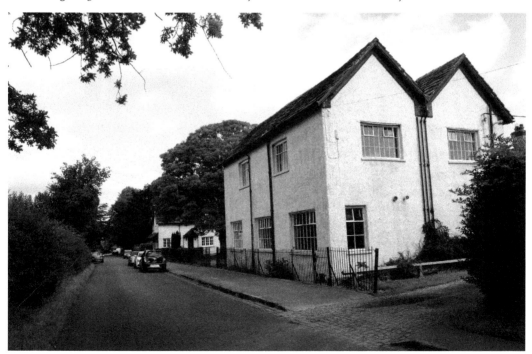

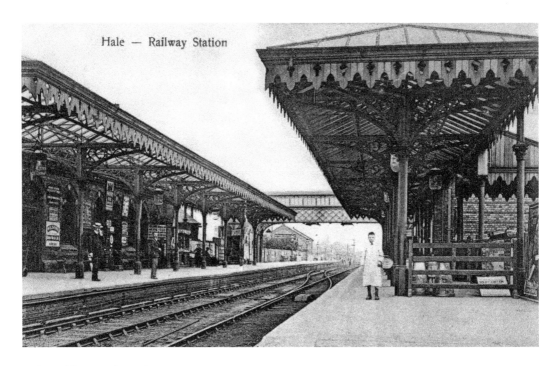

Hale — Railway Station

Hale, Ashley Road, 1906

Hale station is 12.8 kilometres (8 miles) south-west of Manchester Piccadilly and was originally named Bowdon Peel Causeway by the Cheshire Midland Railway. It opened on 12 May 1862, initially running from Altrincham to Knutsford. The Cheshire Midland Railway was finally amalgamated into the CLC, on 15 August 1867, the company remaining independent until the establishment of British Rail in 1948. Bowdon Peel Causeway became Peel Causeway on 1 January 1899 and on the same date in 1902 it was renamed Hale.

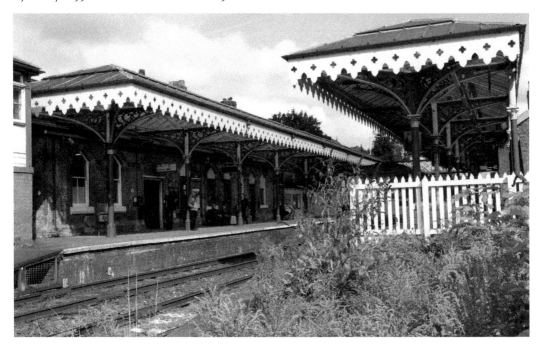

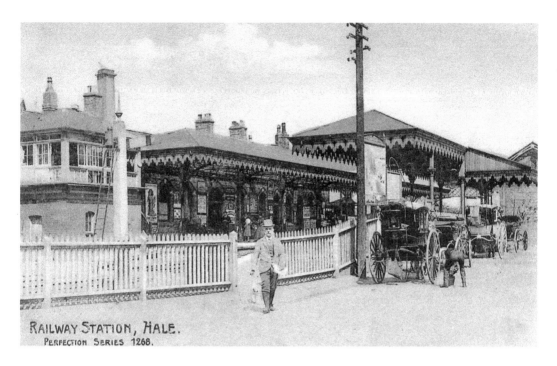

RAILWAY STATION, HALE.
PERFECTION SERIES 1268.

Hale Station and Signal Box, Ashley Road, *c.* 1900

The station is Grade II listed, with the listed signal box of 1876, closing 22 July 1991. The goods yard closed 2 December 1963.The arrival of the railway in the mid-nineteenth century saw the village of Hale change from one with an agricultural base, to a commuter area for the middle classes and merchants, serving the city of Manchester. Next to the station is the Cheshire Midland public house, which has a very distinctive pub sign showing the company's coat of arms.

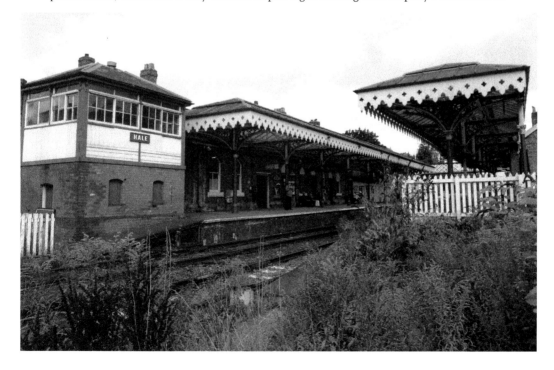

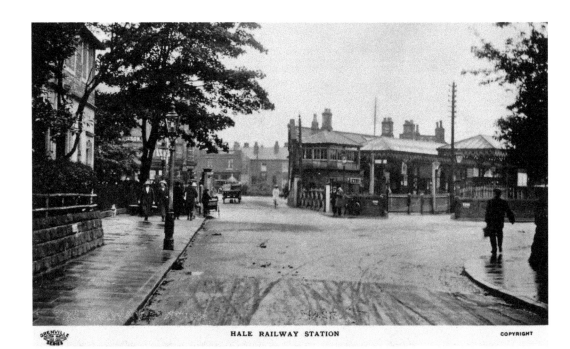

HALE RAILWAY STATION COPYRIGHT

Hale, Ashley Road, 1911

This view of the centre of Hale in 1911 shows the railway station on the right-hand side and the signal box next to it. The level crossing allows traffic to cross Ashley Road, where a cyclist can be seen on a somewhat wet day. Today there are modern residential developments opposite the signal box. On the far left is the Cheshire Midland public house, named after the company who constructed the Altrincham–Knutsford section of the line and station, opening 12 May 1862.

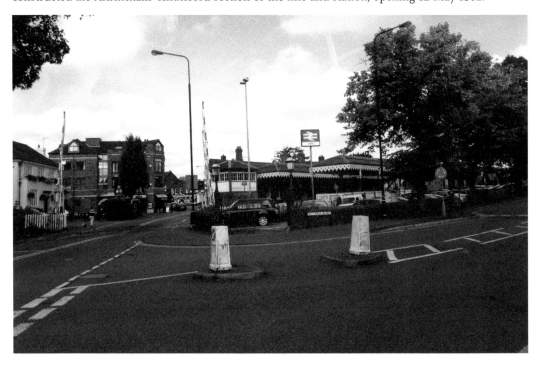

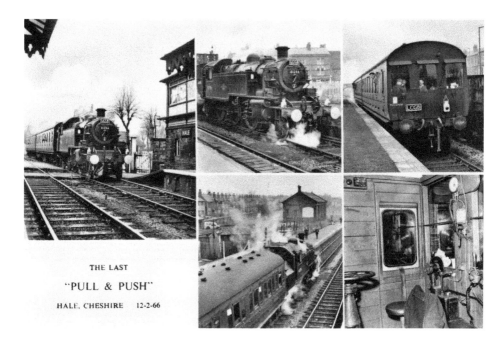

THE LAST

"PULL & PUSH"

HALE, CHESHIRE 12-2-66

The Last 'Pull and Push', Hale, Ashley Road, 12 February 1966

This was the original Pull and Push Farewell Railtour, organised by the Locomotive Club of Great Britain. Due to demand there was a duplicate tour which ran on Saturday 5 February 1966. Both used locomotive number 41286. The route ran from Earlestown to Warrington Bank Quay; Hartford Junction (LNW) and (CLC); Middlewich; Sandbach; Hale; Skelton Junction; Warrington (Arpley); Ditton Junction; Farnworth and Bold; St Helens (Shaw St); St Helens Junction; returning to Earlestown. It arrived at Hale 13.27, departing 13.42 and passing through Altrincham 13.45.

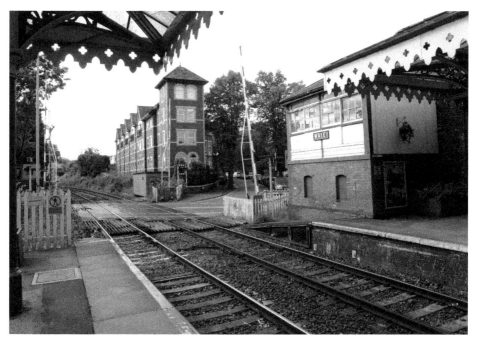

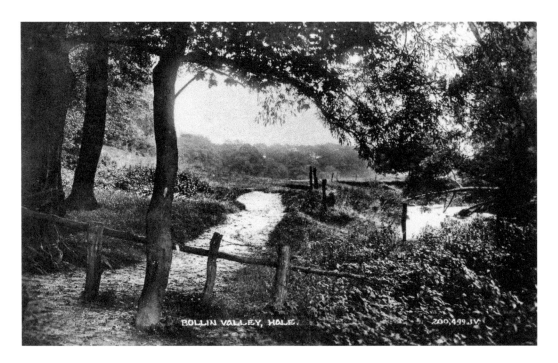

The Bollin Valley, Ashley Road, Hale, c. 1900

The River Bollin rises in the foothills of the Pennines and flows through Macclesfield, Wilmslow, Hale, Bowdon and Dunham and, as with the River Mersey, eventually joins the Manchester Ship Canal about 30 miles from its source. The Mid Cheshire Line crosses the Bollin Valley and its river, to the south of Hale and the urban sprawl of Greater Manchester. The wider district here supports fallow deer, birds of prey, kingfishers and otters. There are a variety of ecosystems to observe.

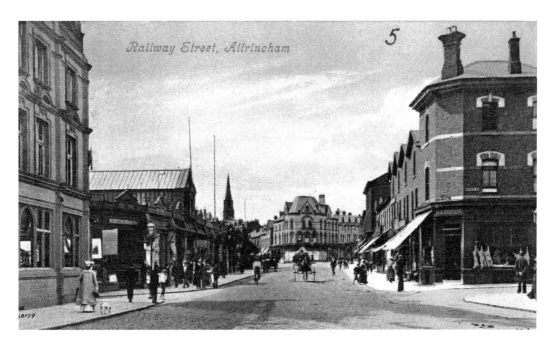

Site of the Former Bowdon Railway Station (left), Railway Street and Regent Road Junction, Altrincham, 1907

Opened 22 September 1849, the Bowdon terminus formed car sheds on the closing of the facility in 1881. Later, in 1931, the depot was made ready for the electrification of the Altrincham to Manchester route. The site closed in December 1991, becoming a car park, as Metrolink did not require it for their services. The photograph of 1907 shows the site of the station on the left, then an engine shed, surrounded by retail premises. It is now the site of Altrincham Hospital.

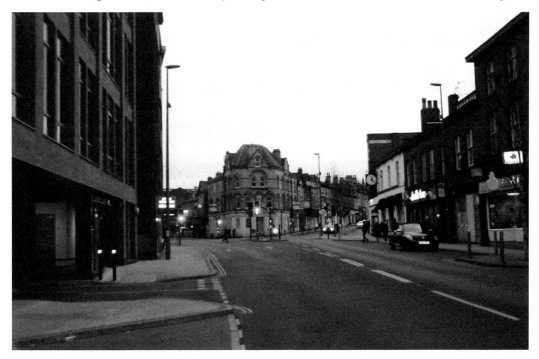

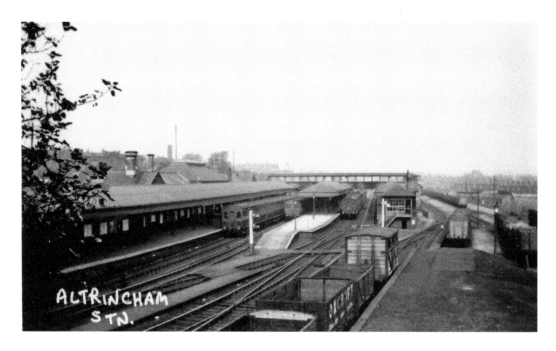

Altrincham and Bowdon, Stamford New Road, 1881
The first railway station served Altrincham between 1849 and 1881 and was constructed by the Manchester, South Junction and Altrincham Railway. It opened 20 July 1849 and was originally located just south of Stockport Road level crossing, near its junction with Stamford Street. It remained here until 4 April 1881, when Altrincham and Bowdon station opened. Bowdon Station to the south, at the junction of Railway Street and Lloyd Street, closed at the same time. There are no surviving remains of the Stockport Road station site.

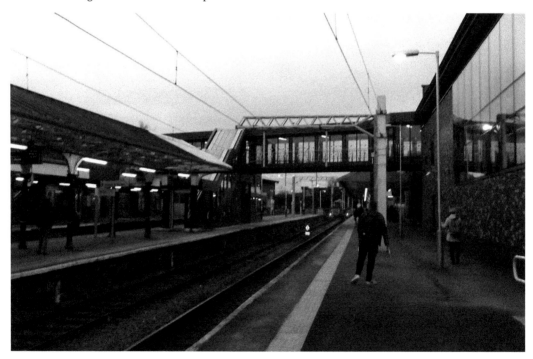

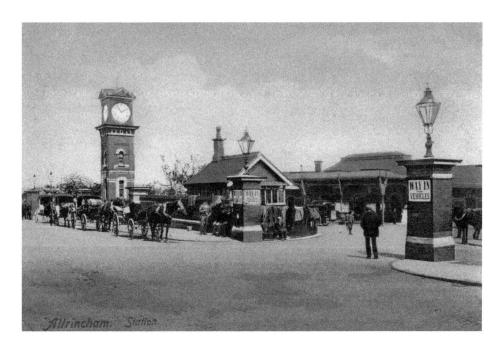

Altrincham and Bowdon, Stamford New Road, *c.* 1910

Altrincham's North Signal Box opened April 1908 and was decommissioned 7 July 1991, with South Signal Box decommissioned 14 July 1968. The station changed its name to Altrincham from 6 May 1974. In 1975 a new booking office was opened on platform four and work to convert the forecourt on Stamford New Road into a bus station began. The canopy over the entrance was removed. It reopened November 1976 as Altrincham Interchange. Later, on 15 June 1992, Metrolink opened. The Interchange was completely redeveloped, officially reopening 7 December 2014.

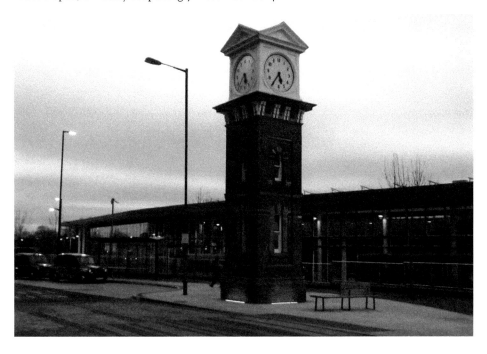

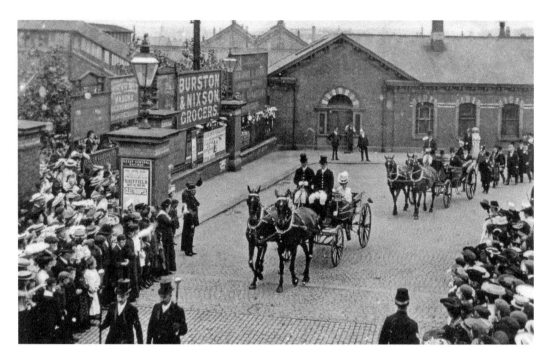

Altrincham Station Approach, Stamford New Road, Showing the Earl of Stamford's 'Homecoming', 1906

Altrincham's goods yard closed 8 October 1966 and the level crossing closed 30 October 1978, replaced by a bridge carrying the A560. Manchester to Altrincham electric trains ceased 24 December 1991, with platforms one and two later reopening for Metrolink trams. A new roof for platform one was constructed in 2006 and the station clock tower on Stamford New Road remains as a Grade II-listed structure. Altrincham Interchange has four platforms in total, with two through platforms for services between Manchester Piccadilly and Chester, via Stockport.

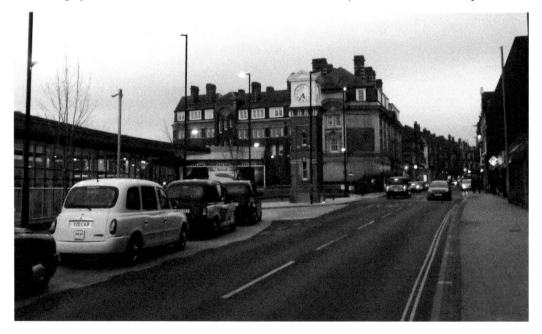

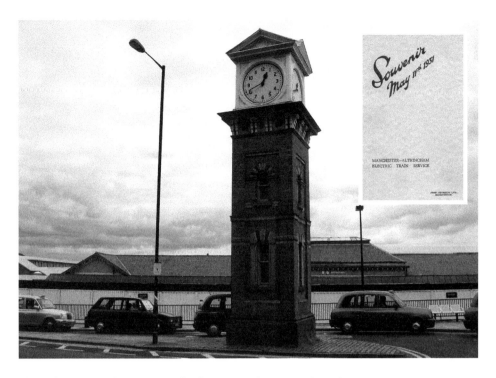

Altrincham Interchange, Stamford New Road, 2013 and 2016

The souvenir brochure (*above, inset*) of the opening of the Manchester to Altrincham electric train service tells us that, 'The Manchester South Junction and Altrincham Railway, serving a rapidly growing residential district between Manchester and Altrincham, is approximately eight and three-quarter route miles in length with a total single track mileage, including sidings, of twenty-eight miles. Between Old Trafford and Sale stations the line is quadrupled.' The line served local suburban populations and linked into the national network, including Chester.

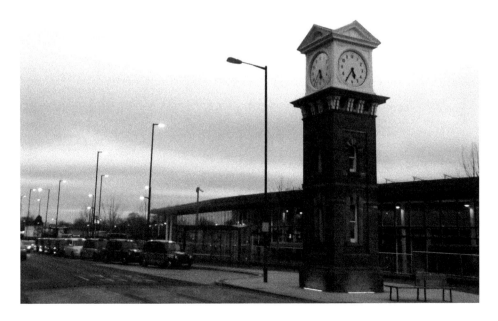

Altrincham Interchange, Stamford New Road, 2013 (Railway left, Metrolink right)

'From Manchester, London Road Station, the line is carried by a viaduct for one and three quarter miles to Cornbrook, where there is a connection with the system of the Cheshire Lines Committee. From Cornbrook the line runs in a cutting to a short tunnel immediately before Old Trafford Station, and from there runs through flat country to Altrincham, where the system of the Cheshire Lines Committee continues to Chester via Knutsford. The present electrification covers the Manchester, South Junction and Altrincham line.'

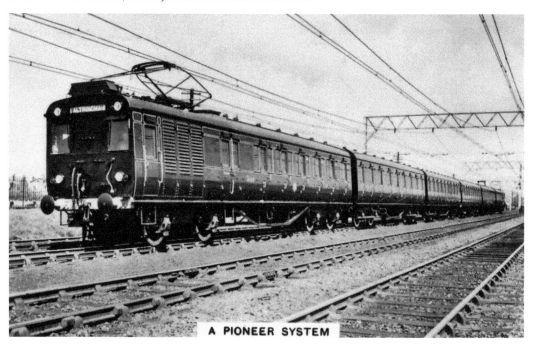

A PIONEER SYSTEM

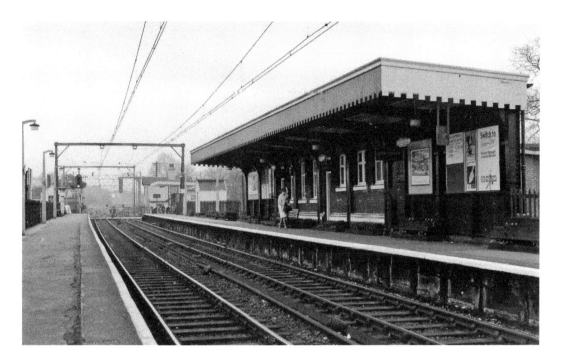

Navigation Road, Altrincham, *c.* 1970

The station is located to the east of Altrincham. There is a level crossing at the southern end of Navigation Road and formerly a signal box, which was here from 1882 until 7 July 1991. The original railway station was opened by the Manchester, South Junction and Altrincham Railway on 20 July 1931, following electrification. The former Altrincham platform is used for Mid Cheshire Line trains and the former Manchester platform became a Metrolink stop on 15 June 1992. Freight trains also operate through the station.

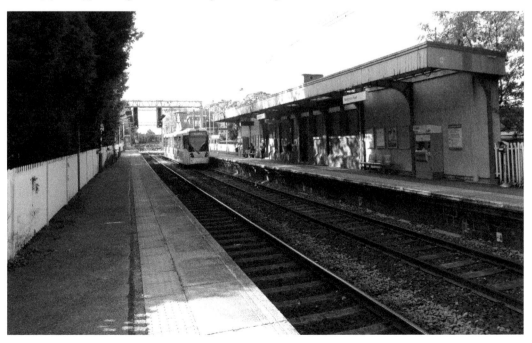

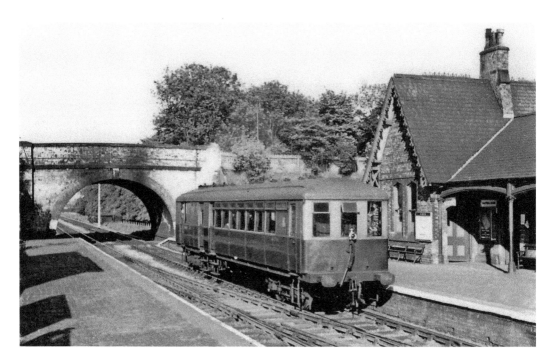

Cheadle, Showing Sentinel Steam Railcars, *c.* 1930 and Stockport Tiviot Dale, *c.* 1960
Cheadle Station opened on 1 February 1866, located on the west side of Manchester Road, and closed on 30 November 1964. On 1 July 1950 the station's goods department was renamed Cheadle North. In the late 1980s the station buildings were converted into a public house called the Cheshire Lines Tavern. Workers cottages were also located here. Westbound departures headed towards Altrincham and Bowdon and West Timperley. Eastbound departures reached Stockport Tiviot Dale (*below*), which opened 1 December 1865 and closed 2 January 1967.

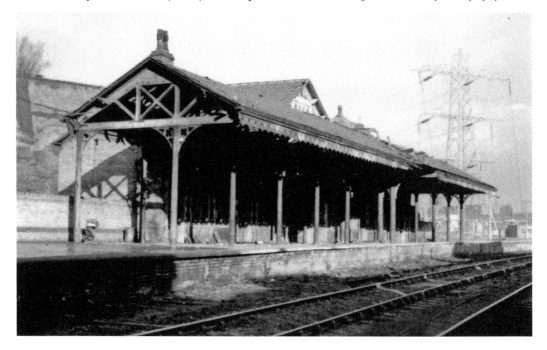

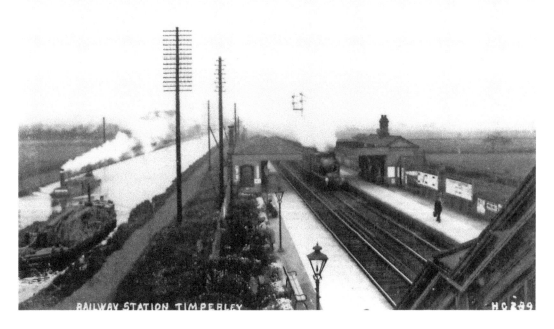

Timperley, Park Road, *c.* 1910

Timperley Station was opened on 20 July 1849 by the Manchester, South Junction and Altrincham Railway and closed to electric trains, as did all the stations on this section of line, on 24 December 1991. This was to allow the construction of the Metrolink tram system, which terminates at Altrincham. The canopy on the Manchester-bound platform was demolished in August 2009 and the former booking office was used by a taxi firm for many years, until 2003. In spring 2010 it became a coffee shop (*below, inset*).

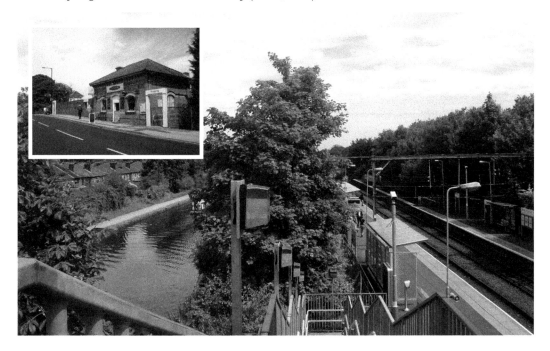

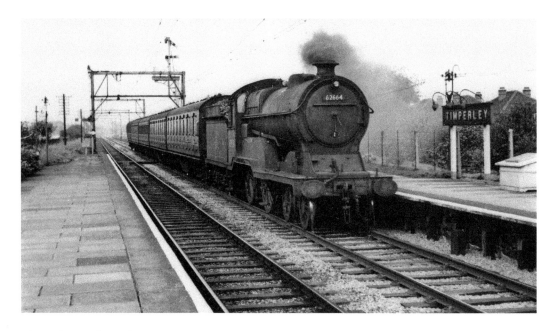

Timperley, Park Road, *c.* 1950

To the south of Timperley Station was Timperley Junction Signal Box, which was constructed in 1897. It contained forty levers and was decommissioned on 10 October 1965. In more recent times Metrolink provided a central reversal siding, just to the south of the station. The station and lines occupy a narrow strip of land between the Bridgewater Canal, to the west and residential properties, to the east. The bridge, carrying Park Road and providing access to the station, spans both the canal and Metrolink (*below, inset*).

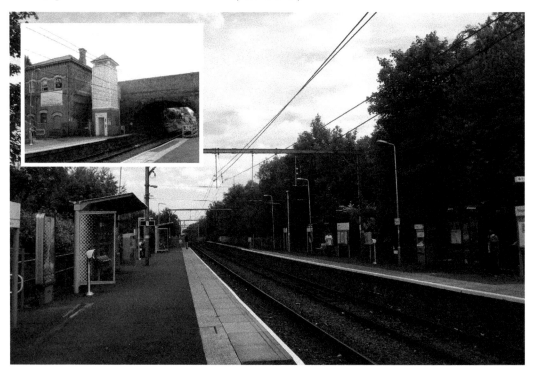

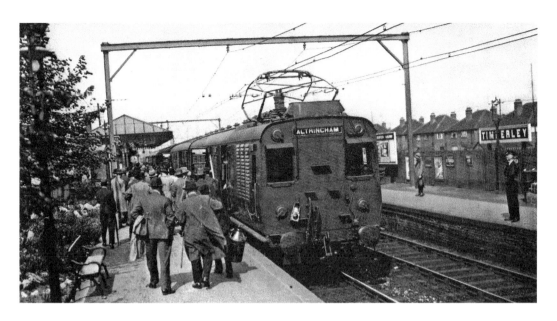

Timperley, Park Road

Shown is an electric train to Altrincham on the first day of service in 1931: 'many people will wonder why the new trains are built on the compartment style instead of the saloon type, which has been the custom recently. It appears at first to be a retrograde idea, but when it is realised that the train only stops at a station for fifteen seconds, passengers can be discharged and taken up much more rapidly by the compartment system than by any other'.

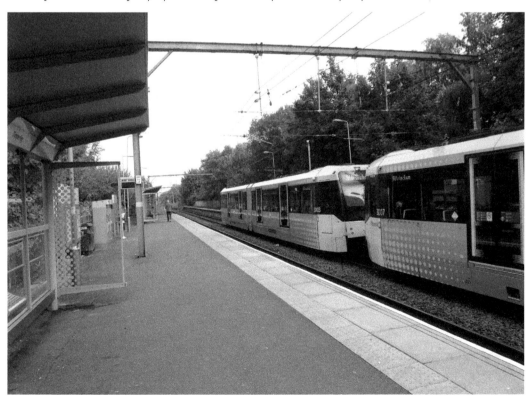

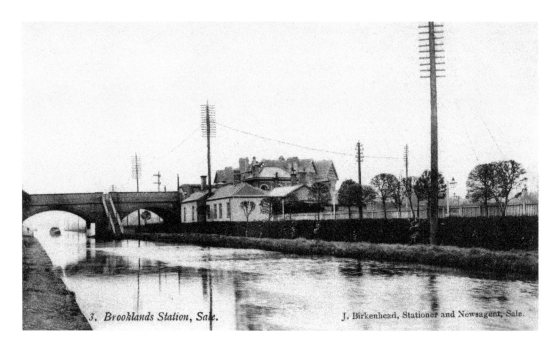

3. *Brooklands Station, Sale.* J. Birkenhead, Stationer and Newsagent, Sale.

Brooklands and the Bridgewater Canal, Junction of Marsland Road and Brooklands Road, 1903

Brooklands Station was opened on 1 December 1859, by the Manchester, South Junction and Altrincham Railway. The station is Grade II listed and was constructed and named following the influence of Manchester banker, Samuel Brooks, who sold the site to the railway company. The 24 December 1991 was the last day that British Rail electric trains ran this route, which reopened on 15 June 1992, as a Metrolink tramline. The tower in the modern image houses a lift.

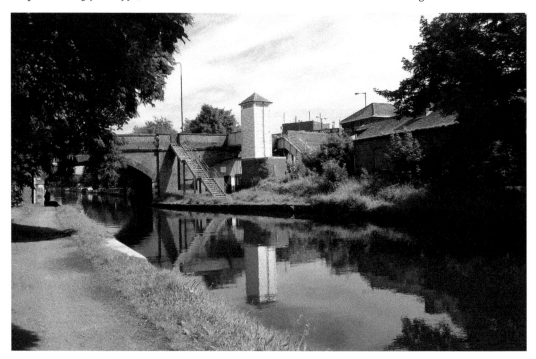

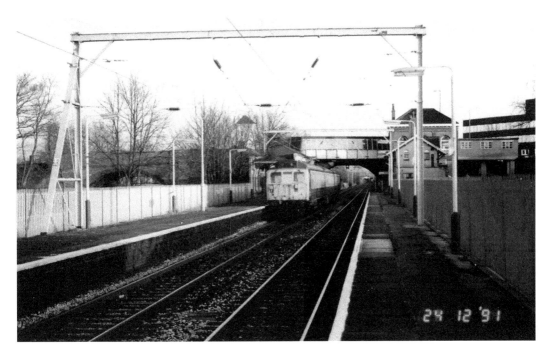

Brooklands, Junction of Marsland Road and Brooklands Road, 1991 and 2012
The station originally served the large mansions and opulent dwellings of the Brooklands area of Sale, which was first developed by millionaire entrepreneur Samuel Brooks, who gave the district his name. By *c.* 1910 there was a goods yard here, which closed in 3 June 1963. The signal box was decommissioned *c.* 1980. In 1990 the station buildings, which are two storey, had become a restaurant and now continue in commercial use. The photograph above was taken on the last day of British Rail service – 24 December 1991.

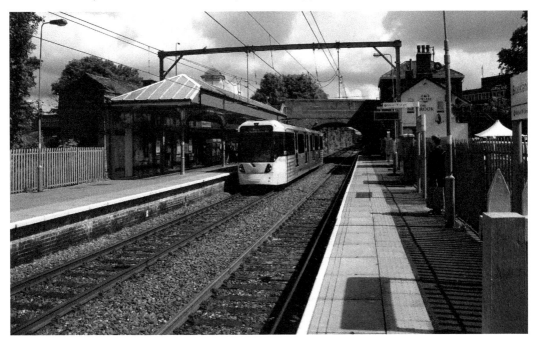

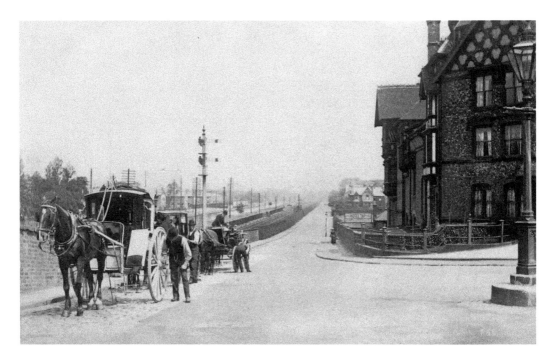

Horse Taxi Rank and Railway Signals, Junction of Marsland Road and Hope Road, 1904
Horse-drawn transport was still prolific in 1904 and the horse taxi ranks on the left are awaiting custom from the Brooklands Hotel, seen on the right, and Brooklands railway station, behind the photographer. Hope Road heads towards Sale; to the left is the railway line, signal and the Bridgewater Canal. Beyond the brick wall, next to the horse taxis, is Sale and Brooklands Cemetery. The Brooklands Tap public house, once a separate part of the hotel, survives next to Marsland House.

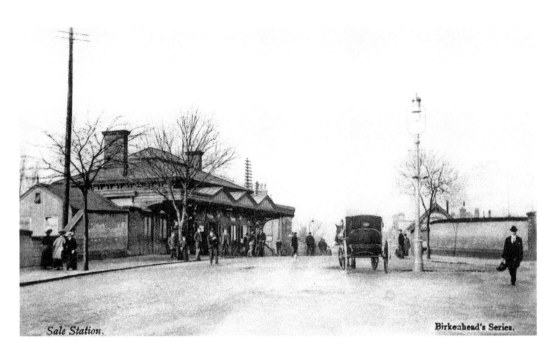

Sale Station. Birkenhead's Series.

Sale, Northenden Road, 1903

The station opened on 20 July 1849 as the Manchester, South Junction and Altrincham Railway, with *Flora* the first engine working this route. John Brogden of Sale built the Manchester–Altrincham section. The station, renamed Sale Moor in 1856 until *c.* 1867, was rebuilt from 1874–77, replacing a wooden building. It became Sale and Ashton on Mersey in 1883 and Sale in 1931, when electric trains were introduced. It closed on 24 December 1991, reopening as a Metrolink station on 15 June 1992.

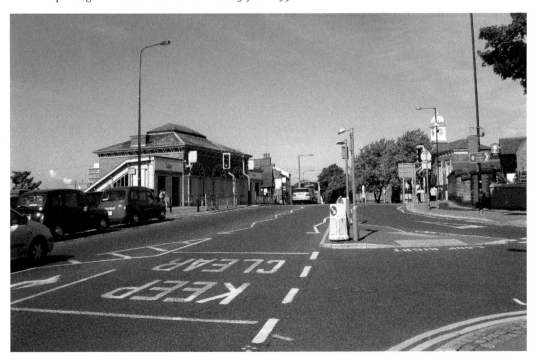

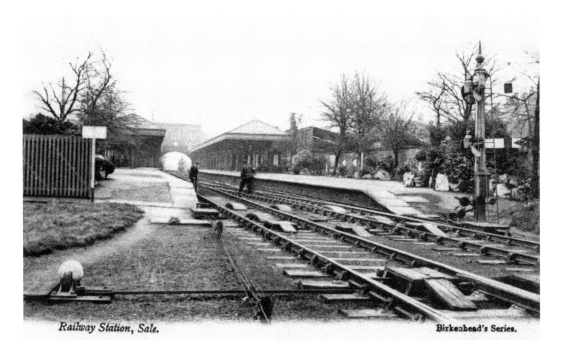

Railway Station, Sale. Birkenhead's Series.

Sale, Northenden Road, Looking Towards Manchester, 1903

In 1903 two things are immediately apparent about the interior of Sale Railway Station. The first is that the length of working platform is much greater in 1903 than today, probably because demand was also greater and trains, therefore, were longer than Metrolink trams of the twenty-first century. The second is that the station and its gardens are immaculately kept. Today the buildings along each platform are 'shells', staff not being necessary for an automated system.

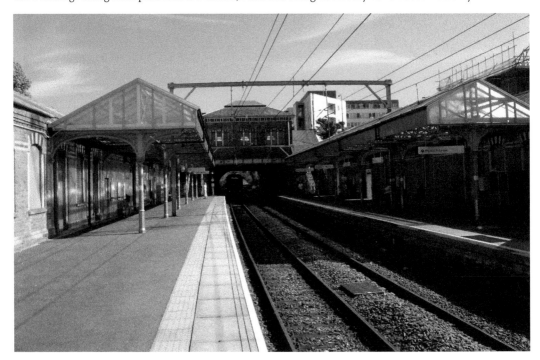

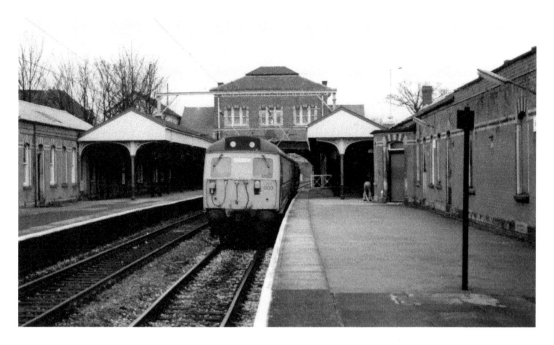

Sale, Northenden Road, 1990

The goods yard at Sale closed on 10 October 1966 and the station's signal box, to the east of the station complex, closed on 1 February 1971. It was constructed in 1903 and had a thirty-three lever frame. By the early twentieth century the railway formed a boundary between commercial and terraced properties to the north and semi-detached and mansion properties to the south, along Northenden Road. The photograph of 29 December 1990 shows a British Rail EMU bound for Altrincham.

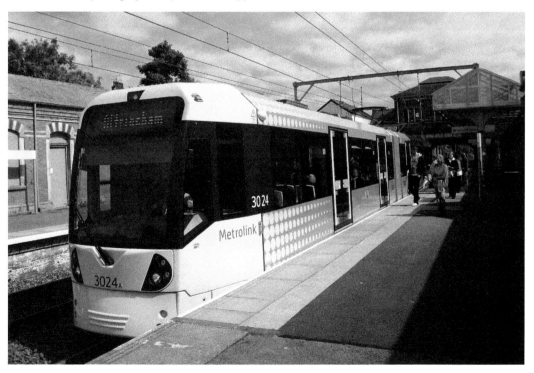

Sale Bridge, from School Road, 1912

Until 1912 the buildings on Sale Bridge, seen in the centre of the above photograph, served as the terminus for trams heading into Sale. After 1912 the bridge was widened and the tramline was extended along Northenden Road and into Sale Moor. Both photographs show Chapel Road to the left and Northenden Road straight ahead. Today there is a bus stop and a taxi rank along this section of road, as well as traffic lights and a pedestrian crossing.

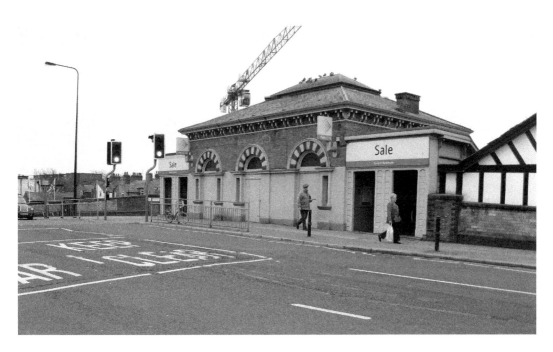

Sale Metrolink Station, Sale Bridge, Northenden Road and T68 Tram, 2012
The station buildings are located on Sale Bridge, which was extensively widened in 1912. The Metrolink network was originally served by thirty-two T68 and T68A trams (shown below). These were phased out in 2012–14 and were replaced by a fleet of M5000 Flexity Swift trams, of which there will be 120 in 2017. The trams had to remain compatible with the former Manchester, South Junction and Altrincham Railway's heavy rail stations, whose platform height was 900 millimetres (35 inches).

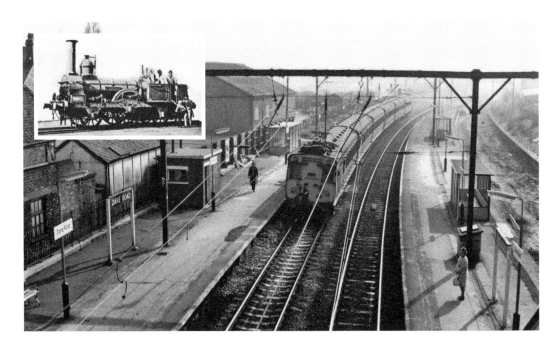

Dane Road, Sale, 1971

Dane Road (Sale) opened on 20 July 1931 and closed on 24 December 1991, converting to a Metrolink tram station on 15 June 1992. It was originally a four-platform railway station, until 9 June 1963, when it was reduced to two platforms post-Beeching Report. The second pair of tracks were located to the far right of the Manchester-bound platform, where there are now trees. It was opened two months after electrification, which was introduced to increase the capacity of the line's rolling stock. The inset image shows *Flora* from Manchester, South Junction and Altrincham Railway, in 1849.

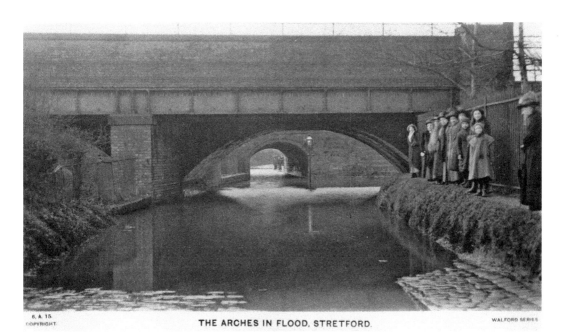

THE ARCHES IN FLOOD, STRETFORD.

The Arches in Flood, Barfoot Bridge, Stretford, *c.* 1905 and from the Towpath, Bridgewater Canal, 2016

Barfoot Bridge crosses the River Mersey at Stretford. The photograph shows the aqueduct carrying the Bridgewater Canal over the river at this point, beyond the bridge in the foreground. This was built by the Manchester, South Junction and Altrincham Railway and shows the large iron girders, which originally supported four locomotive tracks across the bridge. There are now just two, which are utilised by the Metrolink tram system. As can be seen, the area was notorious for flooding.

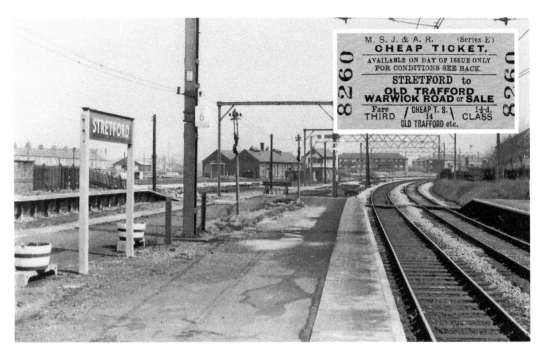

The inset image shows a ticket reading:

M. S. J. & A. R. (Series E)
CHEAP TICKET.
AVAILABLE ON DAY OF ISSUE ONLY
FOR CONDITIONS SEE BACK.
STRETFORD to
OLD TRAFFORD
WARWICK ROAD or SALE
Fare / CHEAP T. S. \ 1½d.
THIRD 14 CLASS
OLD TRAFFORD etc.

8260

Stretford, Edge Lane, Looking Towards Manchester, 28 April 1969
The station was originally named Edge Lane for the first two months after opening. Its goods yard closed 5 December 1966, with this photograph of 1969 looking towards Old Trafford and Warwick Road stations. Today, Metrolink trams serve the line, which was electrified in May 1931. When the railway was first opened in 1849, Stretford's population was 4,998 by 1851, and 8,757 by 1861. Horse-drawn buses once linked Edge Lane to Stretford station and to nearby Urmston Station, also a CLC concern. The inset image above shows a MSJ&AR ticket, dated 12 January 1937.

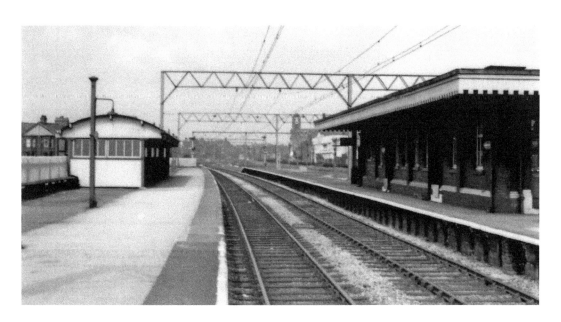

Warwick Road, Old Trafford, c. 1950 and Derelict Platforms from Metrolink Station, 2016
Opened by the Manchester, South Junction and Altrincham Railway as the Manchester Art Treasures Exhibition, from 5 May to 17 October 1857. The station reopened as Old Trafford Cricket Ground in 1862, until 1866, on match days only. It continued to open for special events and for cricket and football matches at both Old Trafford stadia. From 11 May 1931, following electrification of the line, the station was renamed Warwick Road and opened daily. It was renamed Old Trafford on conversion to a Metrolink station.

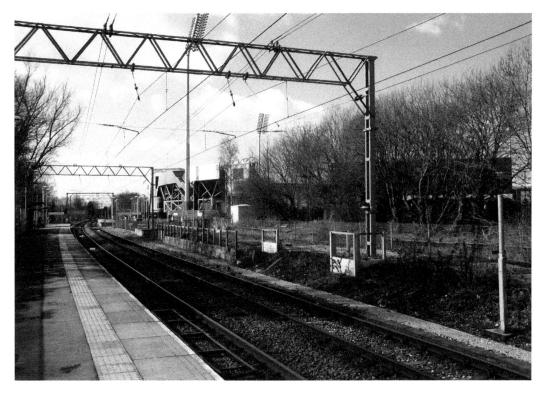

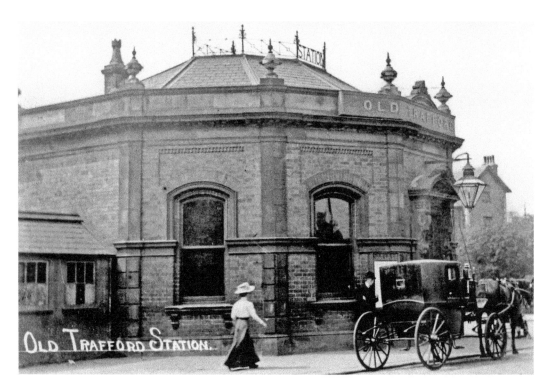

Old Trafford, Junction of Talbot Road and Seymour Grove, *c.* 1900

Old Trafford Station, known as Trafford Bar since Metrolink, was opened 20 July 1849 by the MSJ&AR. The main station buildings were constructed over the tracks directly above a tunnel (*below, inset*), which is 129.8 metres in length (142 yards). Old Trafford Station signal box opened in 1886 and closed 5 December 1965. The goods yard closed 1 September 1958. North of Old Trafford was Cornbrook station, operational from 1856–65 and now the name of a modern Metrolink tram stop, close to the original site.

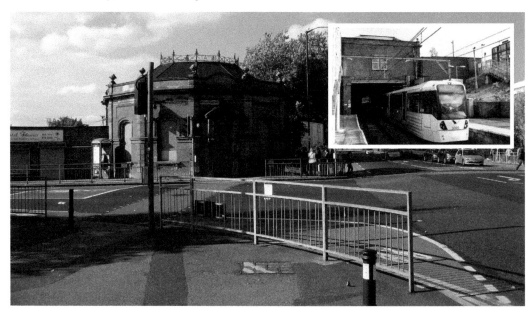

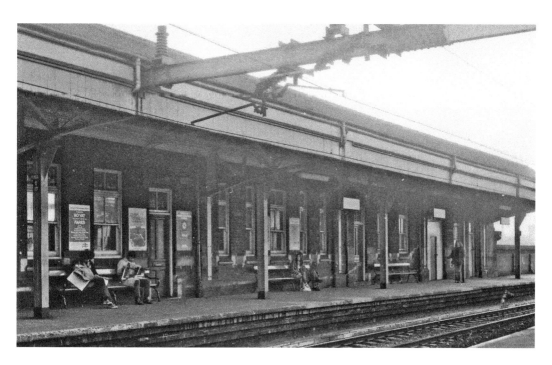

Deansgate, Junction of Deansgate and Whitworth Street West, c. 1970

The station opened as Knott Mill and Deansgate on 20 July 1849 by the Manchester, South Junction and Altrincham Railway. Its wooden station buildings were close to the annual Knott Mill fair. In 1884 Manchester Corporation noted the shabby appearance of the station and improvement plans were submitted, but these were not acted upon until 1891, with the rebuilding completed in 1896. Knott Mill and Deansgate station was renamed Deansgate on 3 May 1971, today it is known as Manchester Deansgate, or Deansgate G-Mex.

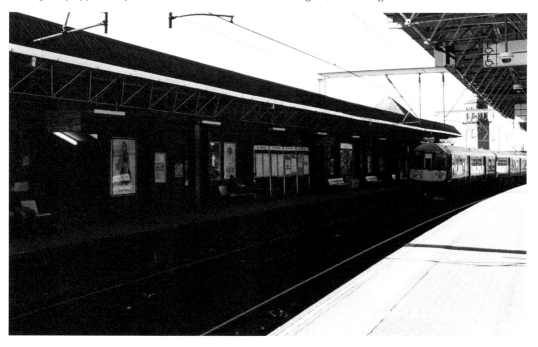

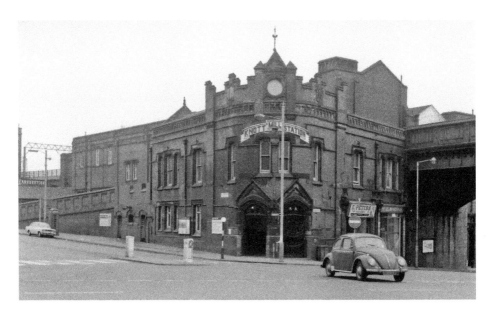

Deansgate, Junction of Deansgate and Whitworth Street West, c. 1965

There are regular eastbound services to Manchester Oxford Road, Manchester Piccadilly and Manchester Airport. The station is close to the G-Mex Exhibition Centre, formerly Manchester Central. Also close by is the Great Northern Warehouse and the Museum of Science and Industry, with Cornbrook Metrolink station to the south west (*below, inset*). A footbridge was built, which connects Deansgate station across Whitworth Street West to the G-Mex Metrolink tram stop. The station still bears the name 'Knott Mill' above the main entrance

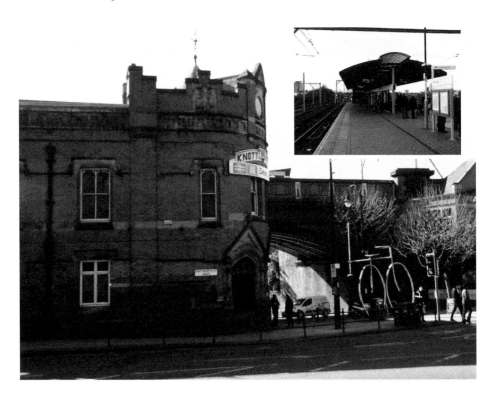

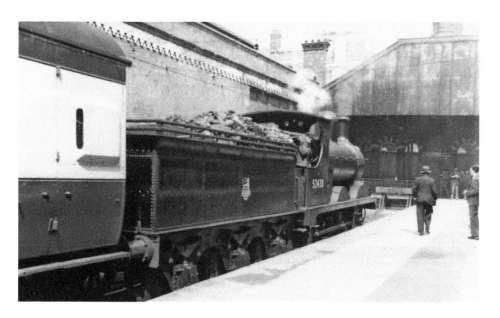

Oxford Road, Junction of Whitworth Street West and Oxford Street, 14 May 1956
Opened on 20 July 1849 by the Manchester, South Junction and Altrincham Railway, and was rebuilt in 1960. It was originally constructed as a station for local trains, serving the southern part of Manchester City Centre. Starting at Manchester Piccadilly the lines stretch westwards towards Warrington Bank Quay, Chester, Llandudno, Liverpool, Preston and Blackpool. Eastbound trains reach Crewe, Leeds, Sheffield and other towns in northern England. Oxford Road station was Grade II listed in 1995. It was the MSJ&AR's headquarters from opening until 1904.

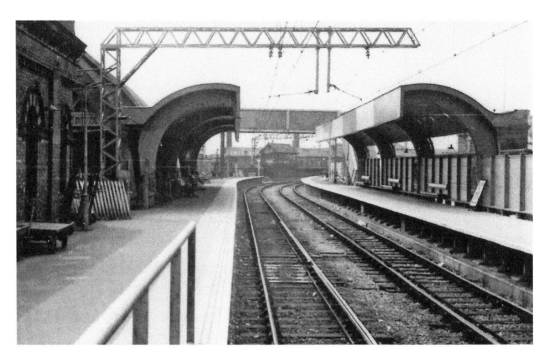

Oxford Road, Junction of Whitworth Street West and Oxford Street, c. 1970

The first station had two platforms and two sidings with temporary wooden buildings. In 1874 it was completely rebuilt, with further reconstruction taking place in 1903–04. From 1931 it was served by the MSJ&AR's 1500V DC electric trains between Altrincham and Manchester Piccadilly. From July 1959 electric trains terminated at Oxford Road, with lines re-electrified and the station rebuilt, reopening on 12 September 1960. Further rebuilding occurred in 1969 and in 1971 the Altrincham line was re-electrified and new rolling stock introduced.

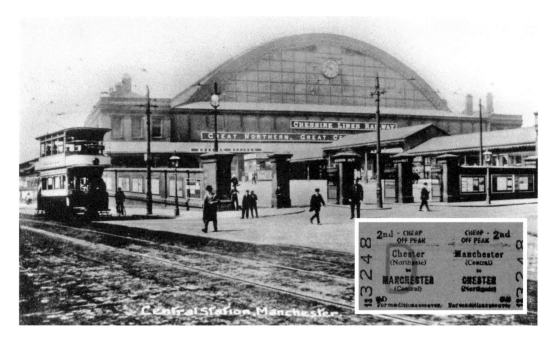

Manchester Central, Windmill Street, c. 1905

The CLC decided that they needed an independent terminus in Manchester. Manchester Central was constructed, together with a new two-track viaduct from Cornbrook to Manchester Central, which was widened in the late 1890s. The viaduct was built with red-brick arches and metal decks at the main crossing points. A temporary station opened for trains to Liverpool in 1877 and Chester trains in 1878. The permanent station opened 1 December 1880, with the temporary station later becoming part of the CLC goods station. The above inset image shows a Chester Northgate return ticket, dated 1962.

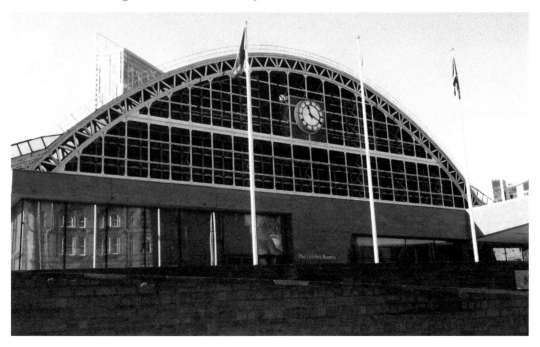

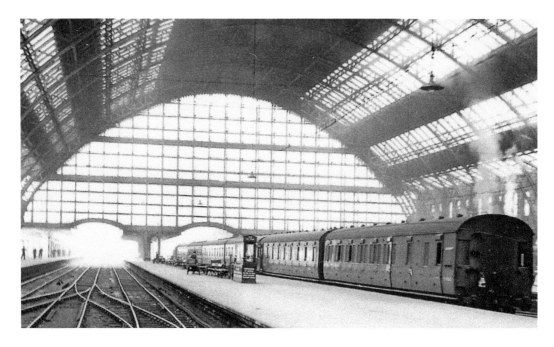

Manchester Central Interior, *c.* 1900

Manchester's fourth railway terminal was erected 1875–80, initially opening with six platforms – three more were added 1906.The original roof had a span of 64 metres (210 feet), its highest point 27.4 metres (90 feet), above the railway. It was initially owned by the Great Northern, Midland and Manchester, Sheffield and Lincolnshire Railway. Central's two signal boxes became one in 1935, this closed 4 May 1969 and the goods yard 7 September 1964. Manchester Central closed May 1969, becoming a car park. It is now an exhibition and conference centre.

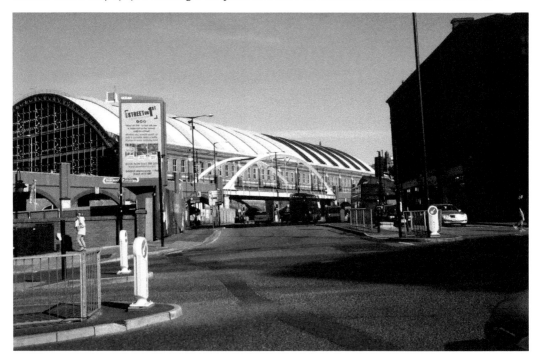

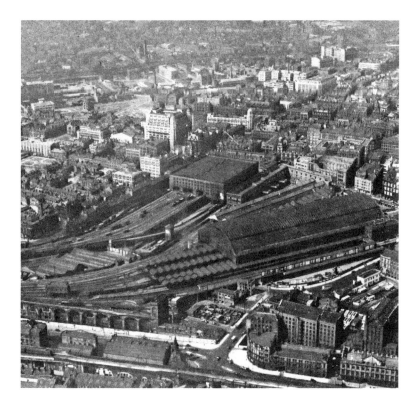

An Aerial View of Manchester Central, 1948

This aerial view shows Manchester Central and the Great Northern Railway's goods warehouse. What is evident about this photograph is the proximity of these two huge structures to one another. Incoming traffic would bring passengers and goods to this complex, and to Manchester, on a massive scale therefore making it a vital regional distribution hub. To the right of the photograph can just be made out the Midland Railway's Midland Hotel, a vital business link from Manchester to the capital.

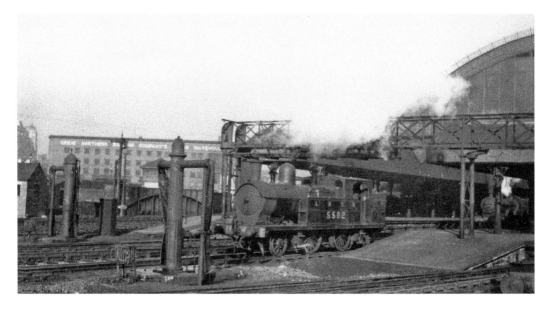

Great Northern Railway's Goods Warehouse from Manchester Central, *c.* 1930

The Great Northern Railway's goods warehouse was built between Manchester Central and Deansgate in 1898–99. Long disused, it is now a listed building and can be seen from Peter Street. A short viaduct connected it to the main CLC line but today only a small section of this remains, close to the Metrolink line. The Great Northern Railway's Goods Warehouse and the listed Victorian terrace, which shielded the warehouse from general view, are now part of the Great Northern development.

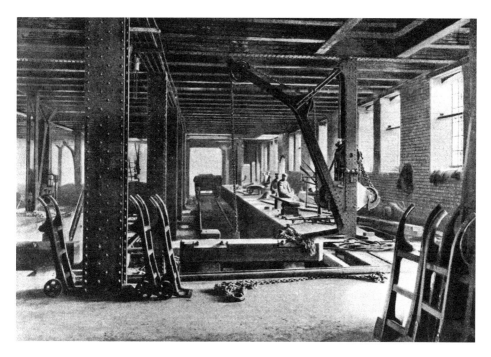

Great Northern Railway's Goods Warehouse Interior, Deansgate, 1898

Manchester Central and the Great Northern Railway's goods warehouse had the advantage of being nearer to the centre of the city than the MSJ&AR. In order for the railway complex to be constructed, the former poor quality housing, industrial complexes and a section of the unsuccessful Manchester and Salford Junction Canal, which had previously occupied the area, were demolished. The warehouse (*below, inset*) was fireproof, had five storeys, closed in 1954 and was a car park until development into a retail complex.

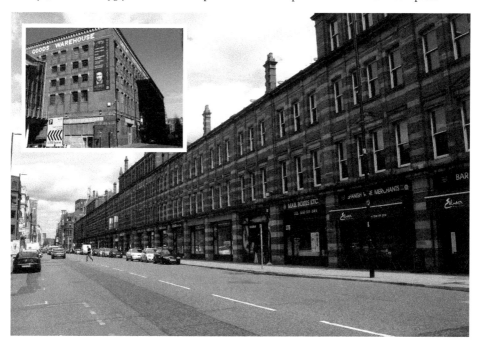

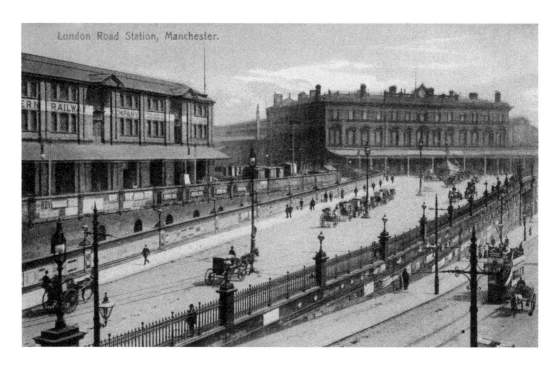

London Road, 1900 and 2015

The Manchester Birmingham line was completed in 1839, with the first London Road station opening in 1842. It was built as the LNWR's terminus for trains from London, reducing the twenty-four hour coach journey to twelve hours by train. In 1866 the former Store Street station was replaced by the Mills and Murgatroyd building, which dominated the station approach until 1967. Further extensions in 1880–83 saw adjacent land used for constructing huge goods sheds and warehouses (*below, inset*), as the Victorian railway infrastructure rapidly expanded.

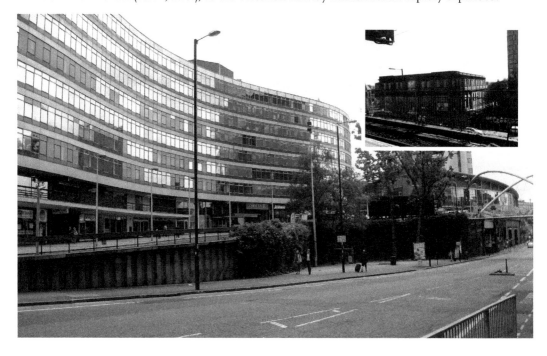

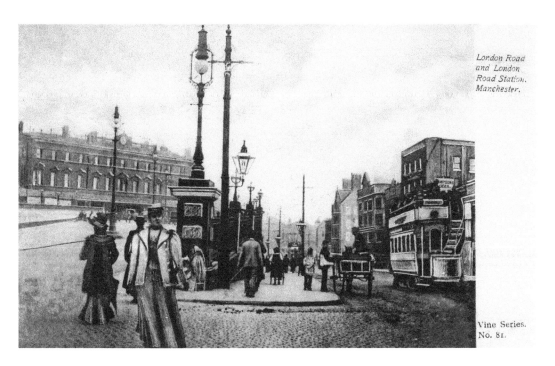

London Road and London Road Station, 1904 and 2015

At the time of the Manchester, South Junction and Altrincham Railway's original electrification in 1931 there were ten stations on the line, namely Manchester, London Road; Oxford Road; Knott Mill and Deansgate; Old Trafford; Cricket Ground (Old Trafford), renamed Warwick Road (Old Trafford); Stretford; Sale; Brooklands; Timperley; and Altrincham and Bowdon. Two new stations Dane Road (Sale) and Navigation Road (Altrincham) opened later in 1931. It was anticipated a journey would take only twenty-four minutes, including the two new stations.

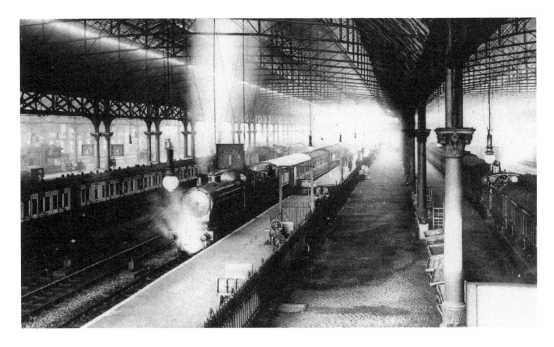

London Road, Platform One, *c.* 1940

The former Manchester, South Junction and Altrincham Railway platforms were on the south side of London Road station before 1957. There were two platforms located on a bridge. Major reconstruction of the station took place before main line electrification in 1960. The final stage of the Crewe to Manchester electrification project began in 1958, yet despite this process of modernisation much of the original station roof, erected in 1881, was retained. Today the station has been further modernised to accommodate the Metrolink system.

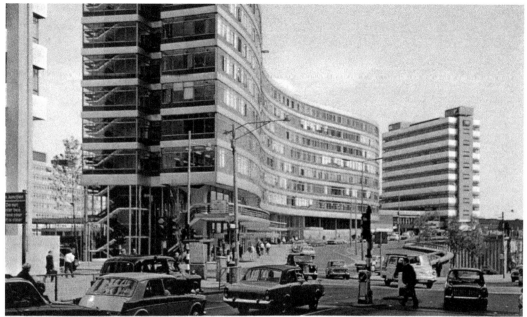

Approach to Piccadilly Station, Manchester.

Approach to Piccadilly, London Road, 1965 and 2016

London Road originally serviced the Manchester and Birmingham Railway and the Sheffield, Ashton-Under-Lyne and Manchester Railway. The name Piccadilly was not introduced until 1960. Today, it remains one of the three main Manchester stations, with routes to London, Glasgow, Edinburgh, Birmingham, Cardiff and Norwich. It is now also a terminus for the Metrolink tram system, with a connecting route to Manchester's other main line station at Hunt's Bank, Victoria – the first time the two have been directly linked.

Piccadilly

In the above image taken on 16 April 1992, number 016 has destination 'Chester' reflected in its window. Once modernisation work had been completed the name of the station was changed to Piccadilly, on 12 September 1960, reflecting the name of the district in which it is located. On 11 May 1966 the station was officially opened by the Lord Mayor. In 1954 platforms 1–4 received an electric supply at 1500 volts DC and from 1960 25KV AC for the remaining ones. Further modernisation of the area occurred when the goods sheds were demolished and goods depots below the platforms were used for Metrolink.

Cheshire Lines Refrigerator Van at Charles Roberts & Co., Haulage, 2 August 1929 and Electric Unit, Piccadilly, March 1980

Charles Roberts & Co. were established 1856 in Wakefield and moved to Horbury Junction in 1873. In 1899 they were registered as a wagon building business. They produced railway wagons, tank wagons, components, body shells for British Rail and tram bodies in the 1950s. During the Second World War the company were involved in the production of the Churchill Tank. The plant was closed in 2005. The above photograph shows a Cheshire Lines refrigerator van awaiting delivery outside Charles Roberts' factory at Horbury Junction.

About the Author

Steven Dickens is from the Flixton area of Manchester and is married to Sarah – they have three sons and three daughters. He is a retired Charge Nurse and college lecturer, whose academic background is in modern history. He has always had an interest in local history and genealogy and has written several journal and magazine articles on these subjects in the past, as well as writing several *Through Time* titles.